BOGOTA
Street
Art

Jacqueline Hadel

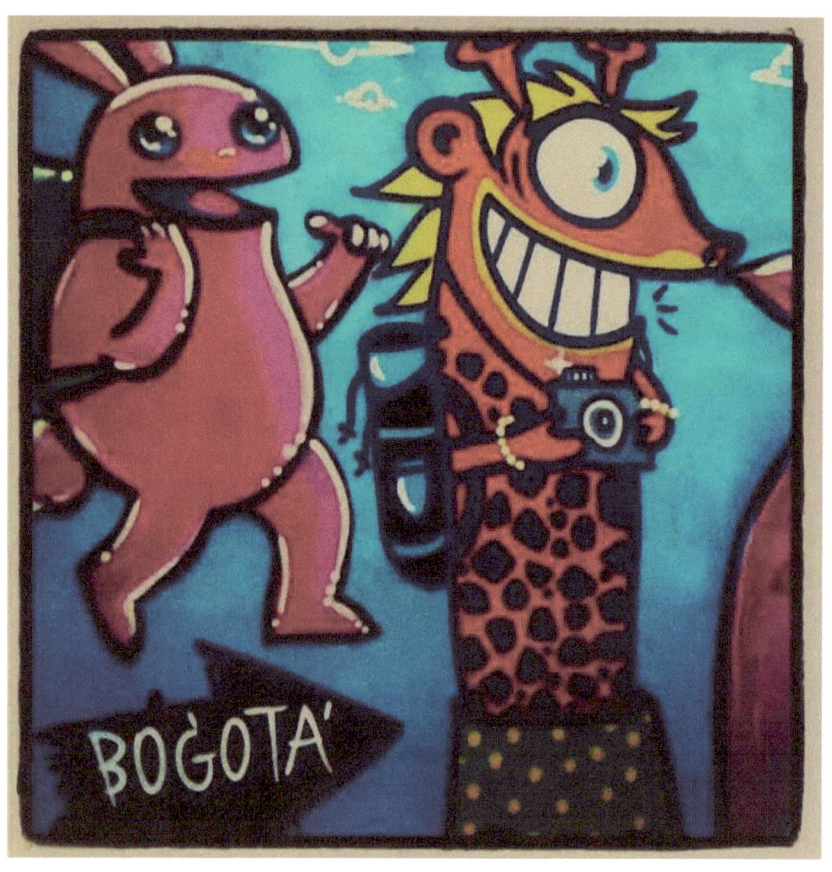

Copyright 2013

Jacqueline Hadel

All rights reserved.

ISBN-13: **978-1484952825**

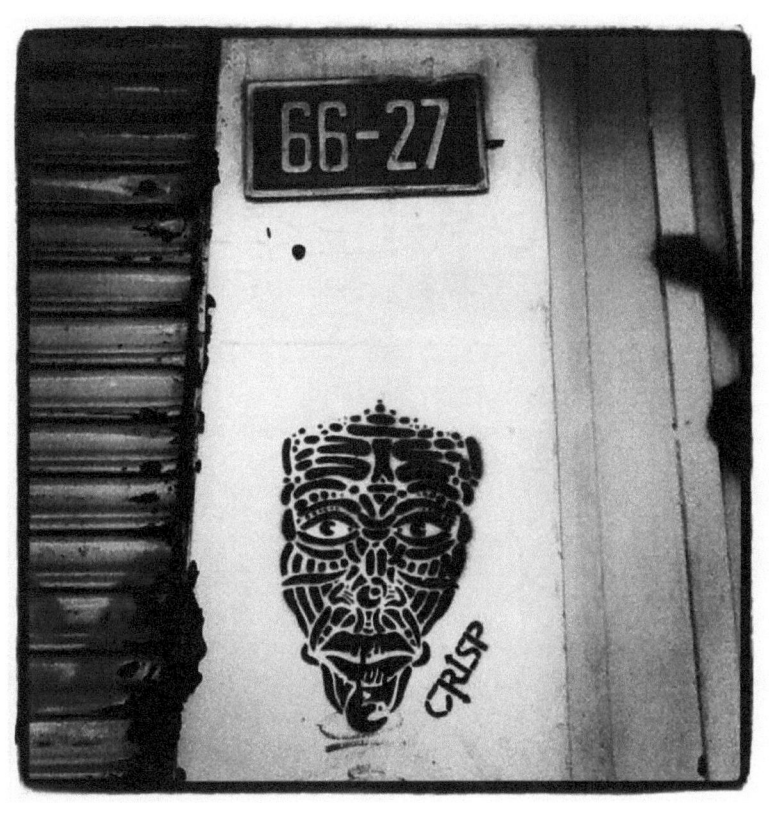

FOR EVERYONE WHO HAS SUPPORTED ME AND IN MEMORY OF CLARA E. GARTRELL, LORETTA FULLER, AND KATIE ANN HADEL

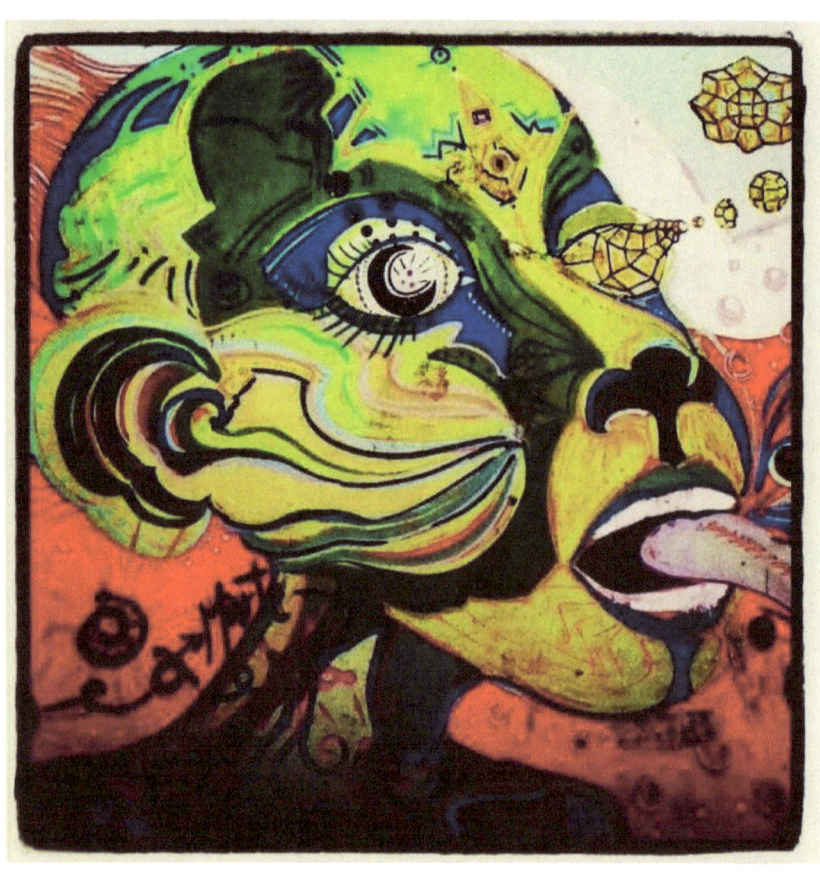

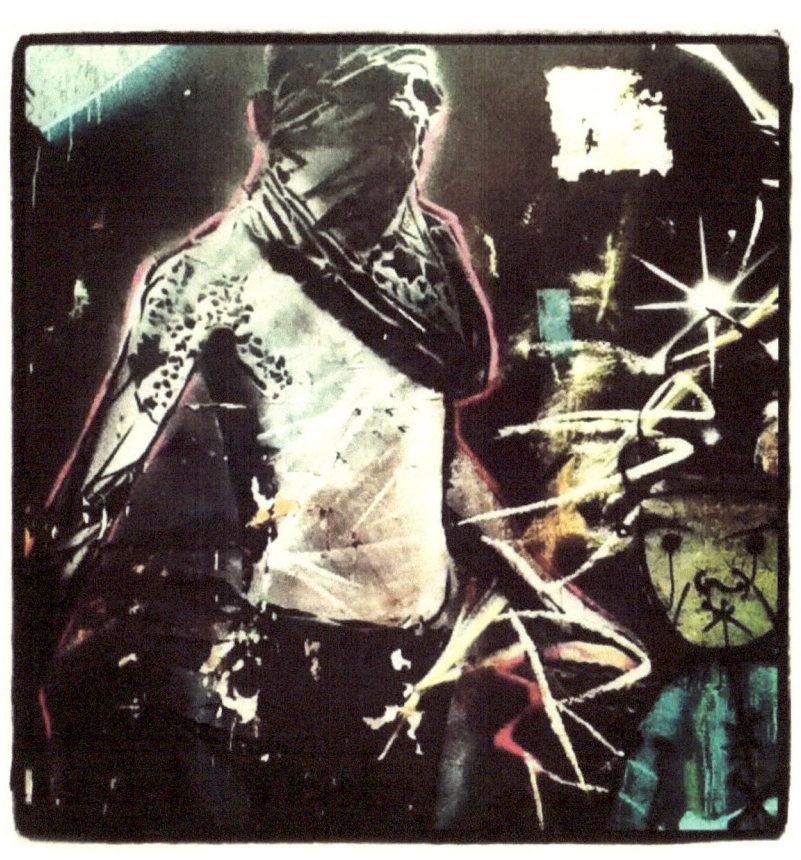

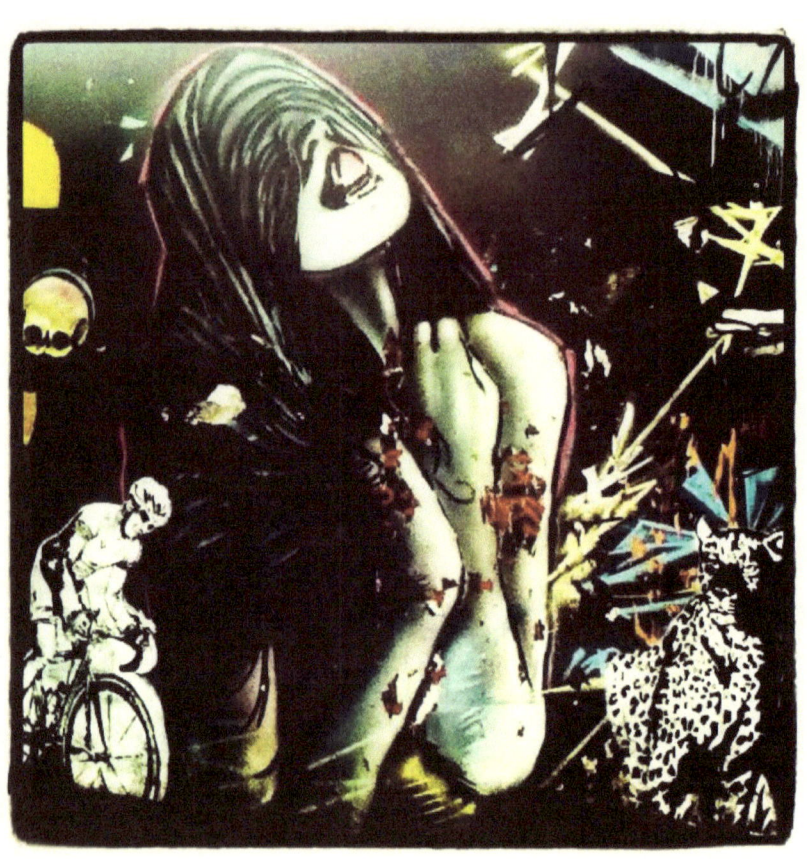

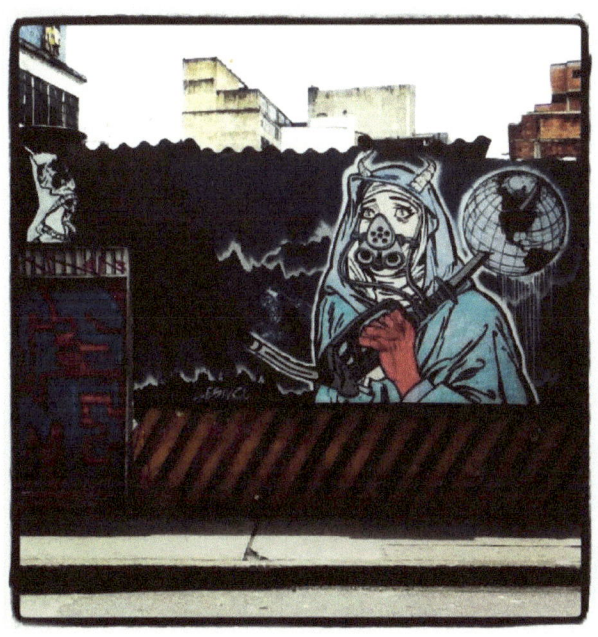

ACKNOWLEDGMENTS

First to Christian P. who unselfishly shared his experience and knowledge of Bogota Street art with me. In doing so, he awakened in me a passion for urban art that I have been chasing all over the globe with my camera ever since.

I spent the last four months of 2012 in Bogota, Colombia and I couldn't (and after long, didn't want to) walk down a street that wasn't decorated in some way by graffiti. Slowly but surely, by dissecting the murals and translating the Spanish slogans covering them, I was able to educate myself to a certain degree about the various political issues within the country and without.

I believe street art is beautiful, intelligent, and that it more often than not, serves as a representation of the disenfranchised entities without popular 'voices.' The deeper I go into the lower income neighborhoods, (dangerous, and at the same time exhilarating) the more brilliant and articulate the images and messages become.

Thanks to the known artists, Crisp, DjLu, Lesivo, Toxicomano, RTZ, Stinkfish, APC crew, Bastardilla, Kaye, Guache, Orfanato, Assi One, Pez, Miko, Nomada, Rodez, and all of the fantastic unknown artists that I unfortunately could not identify.

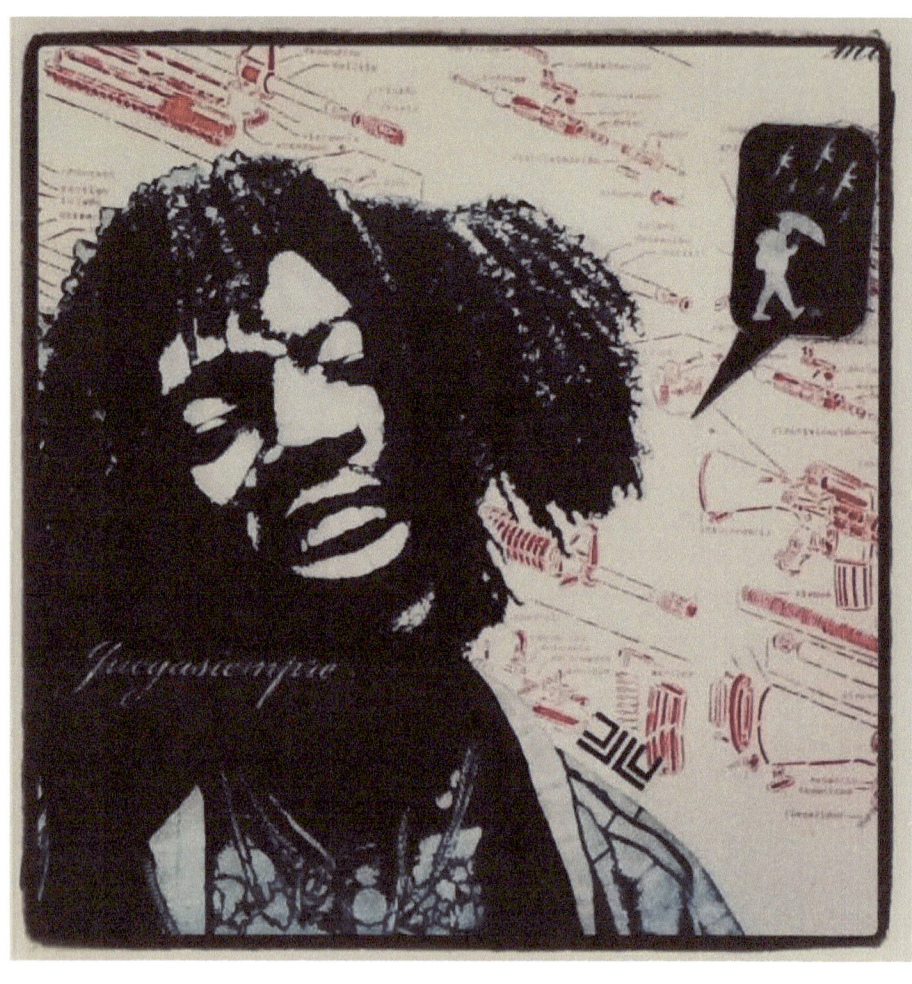

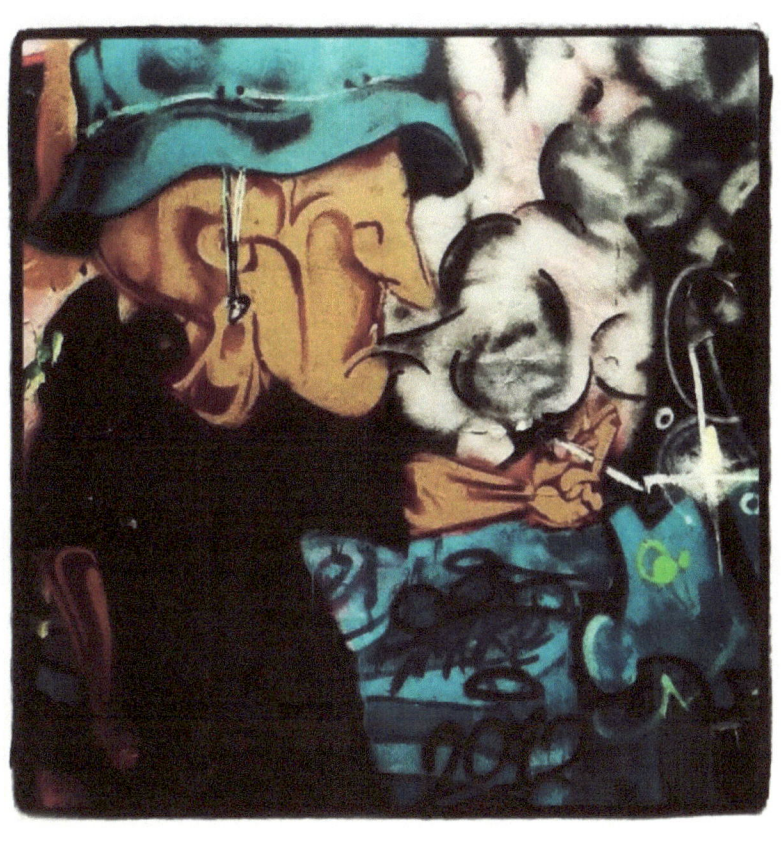

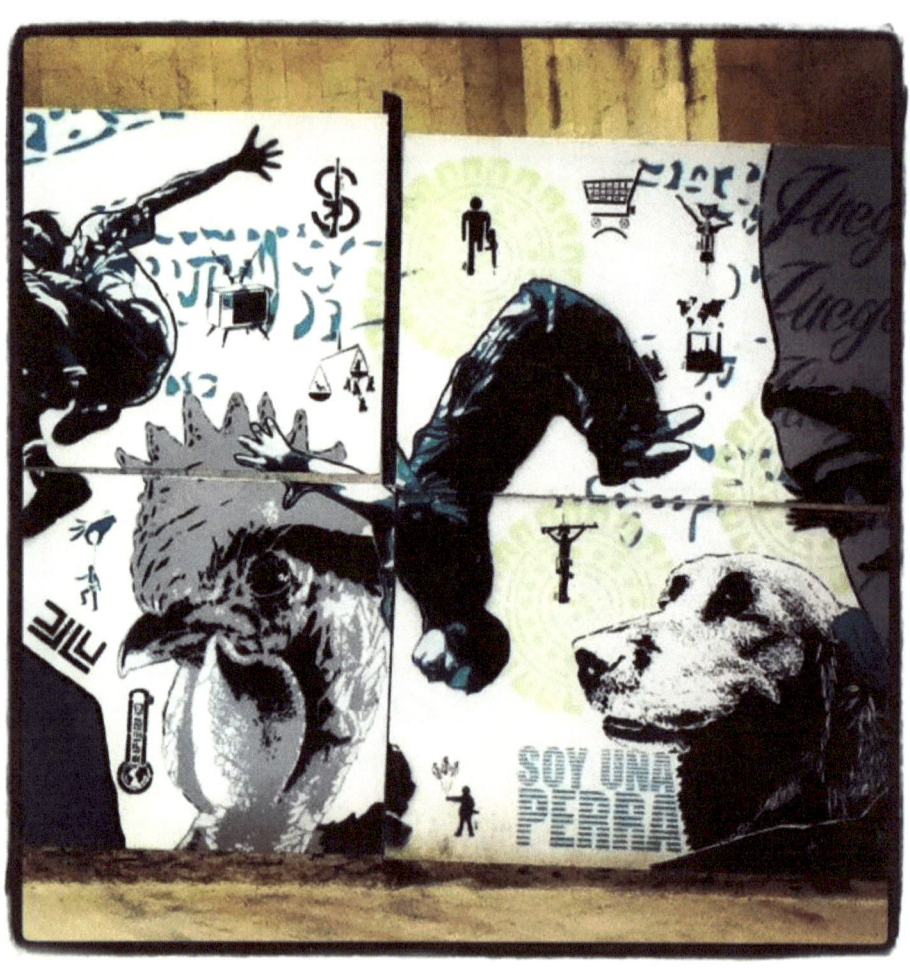

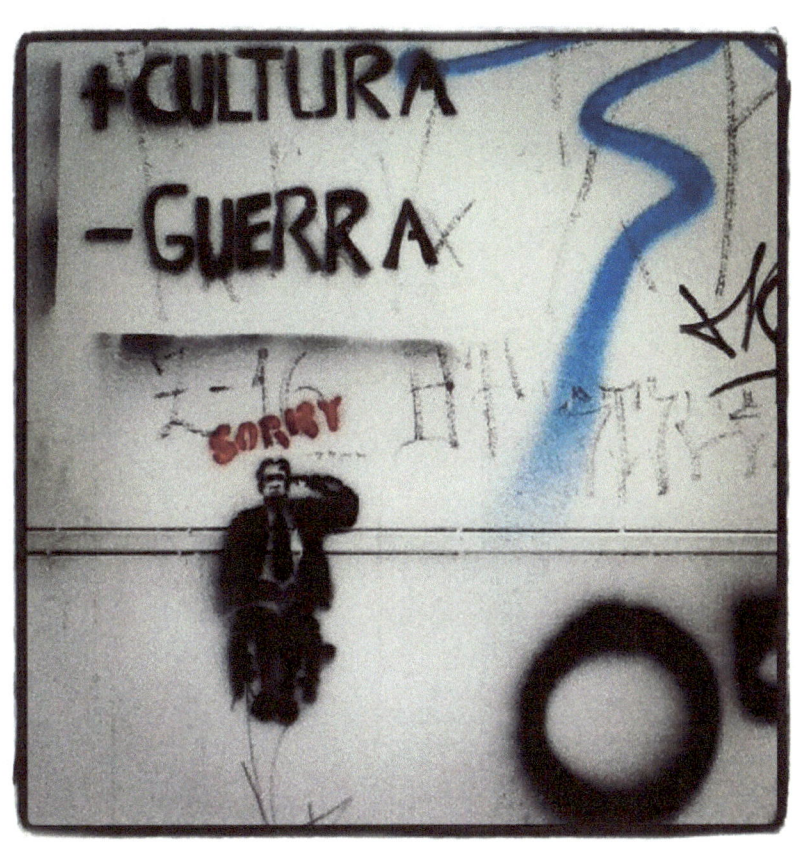

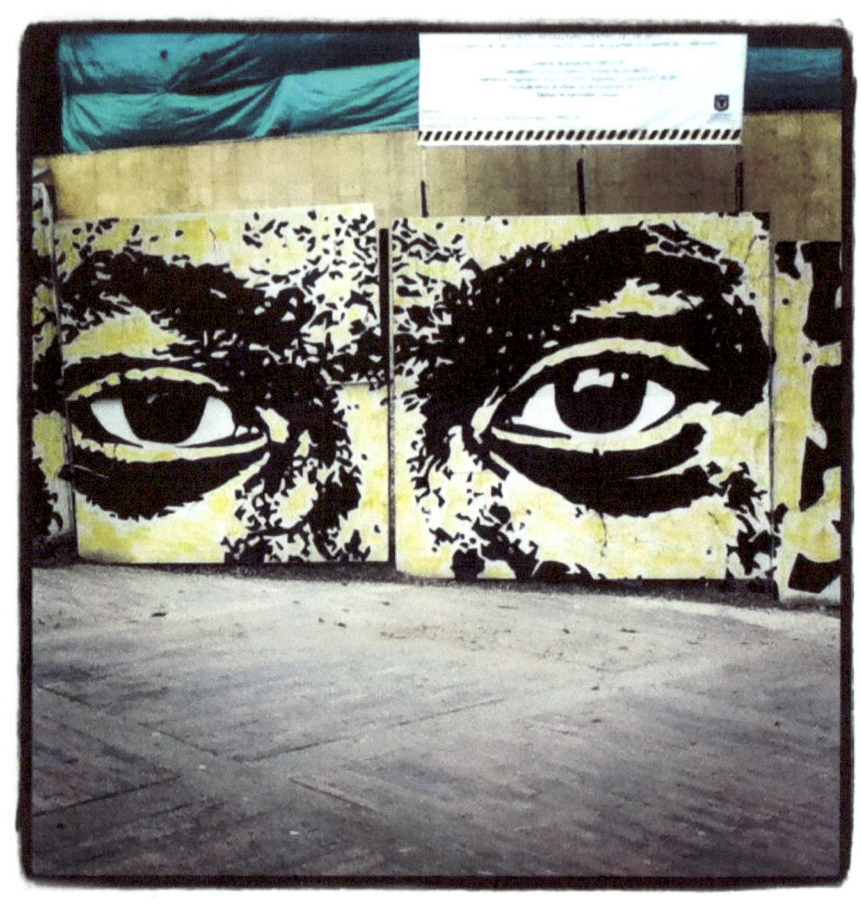

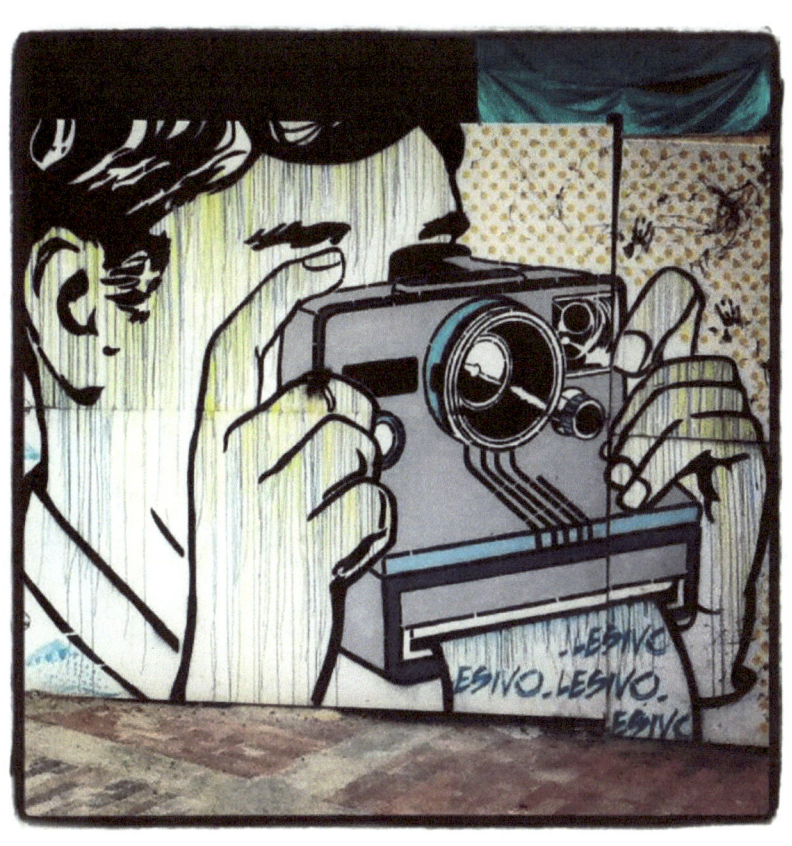

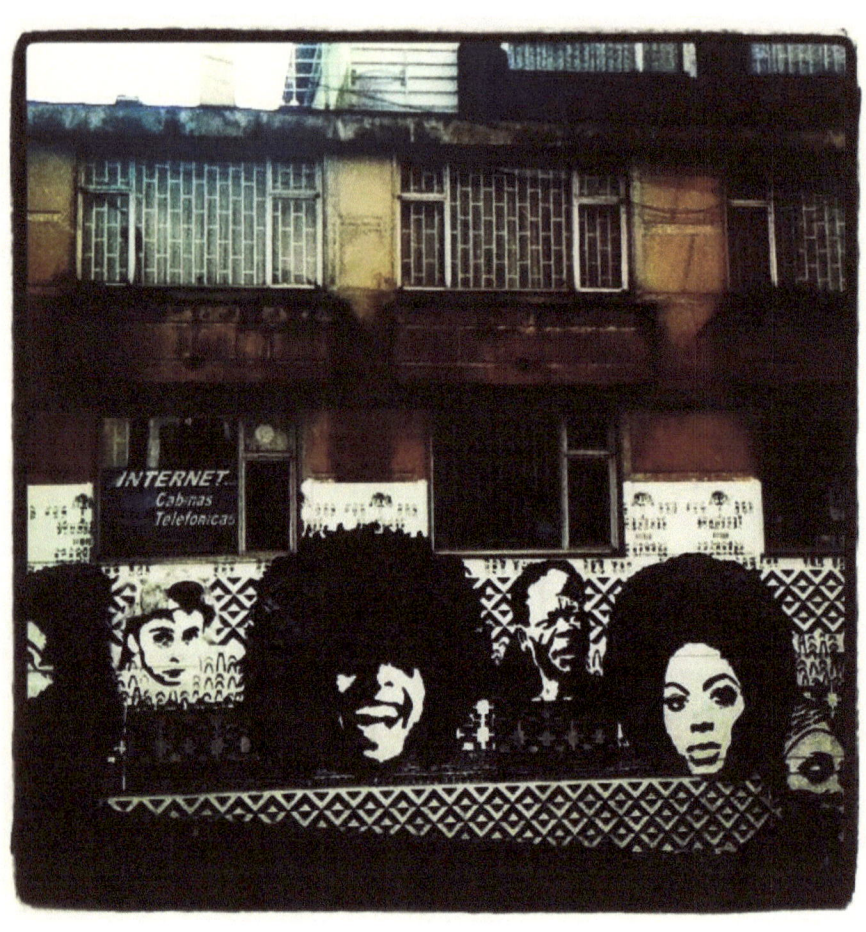

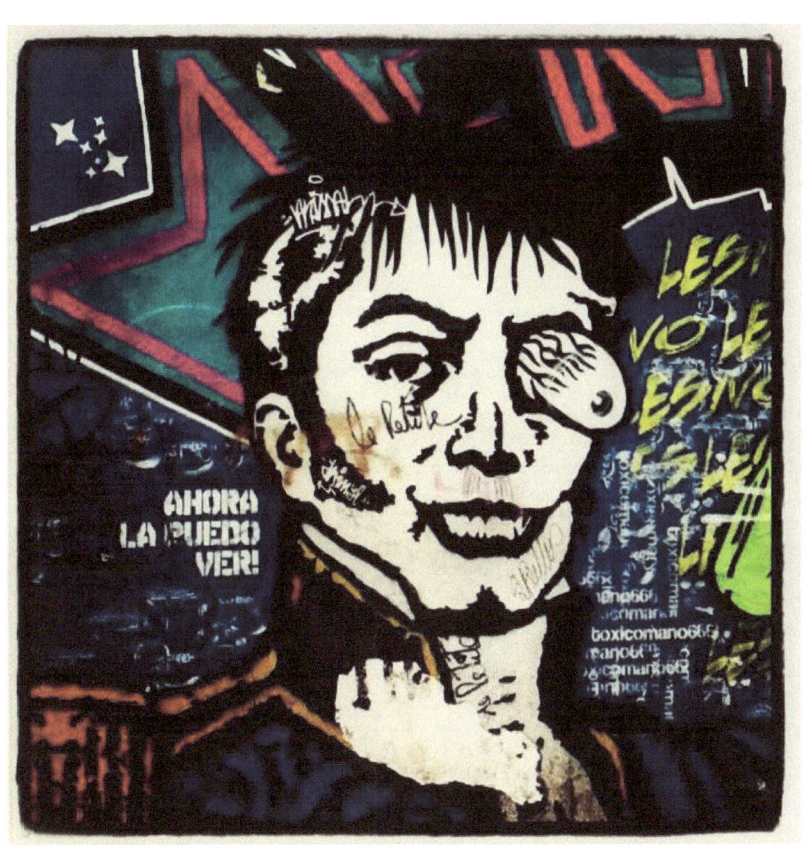

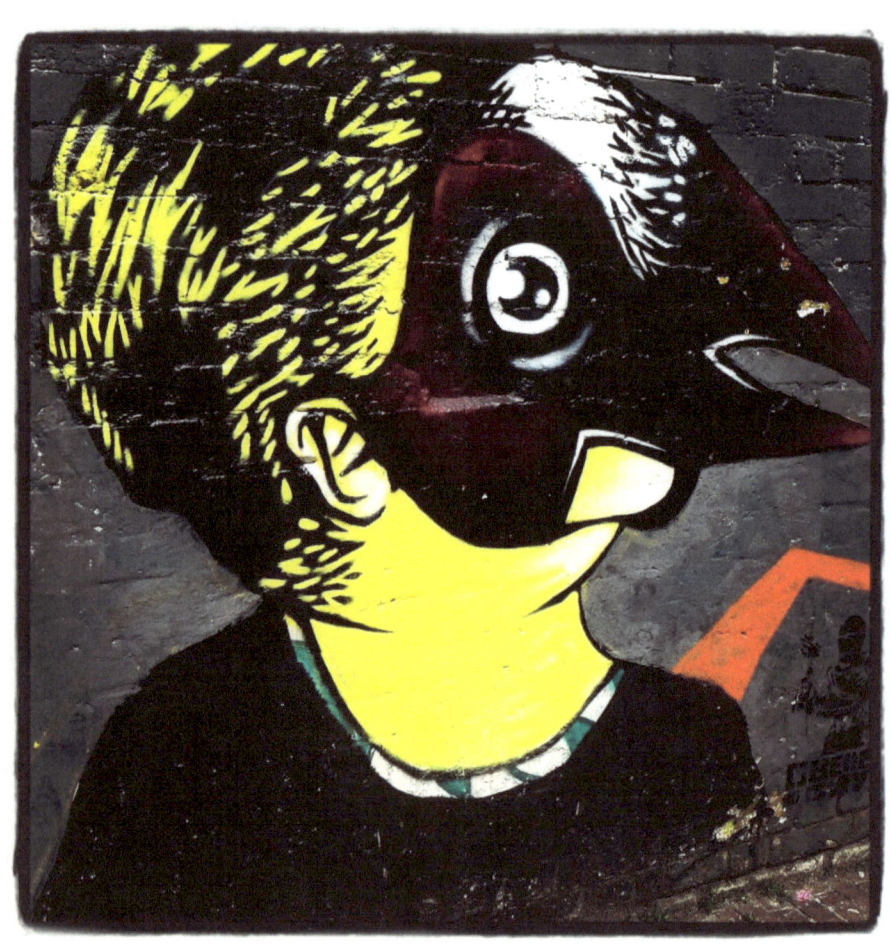

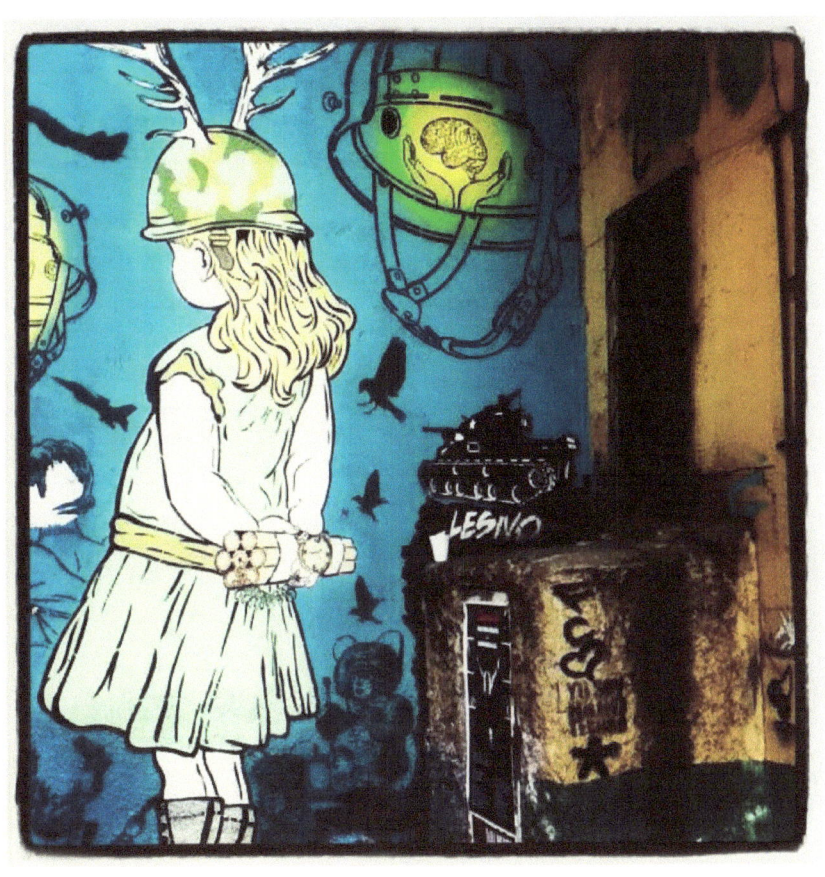

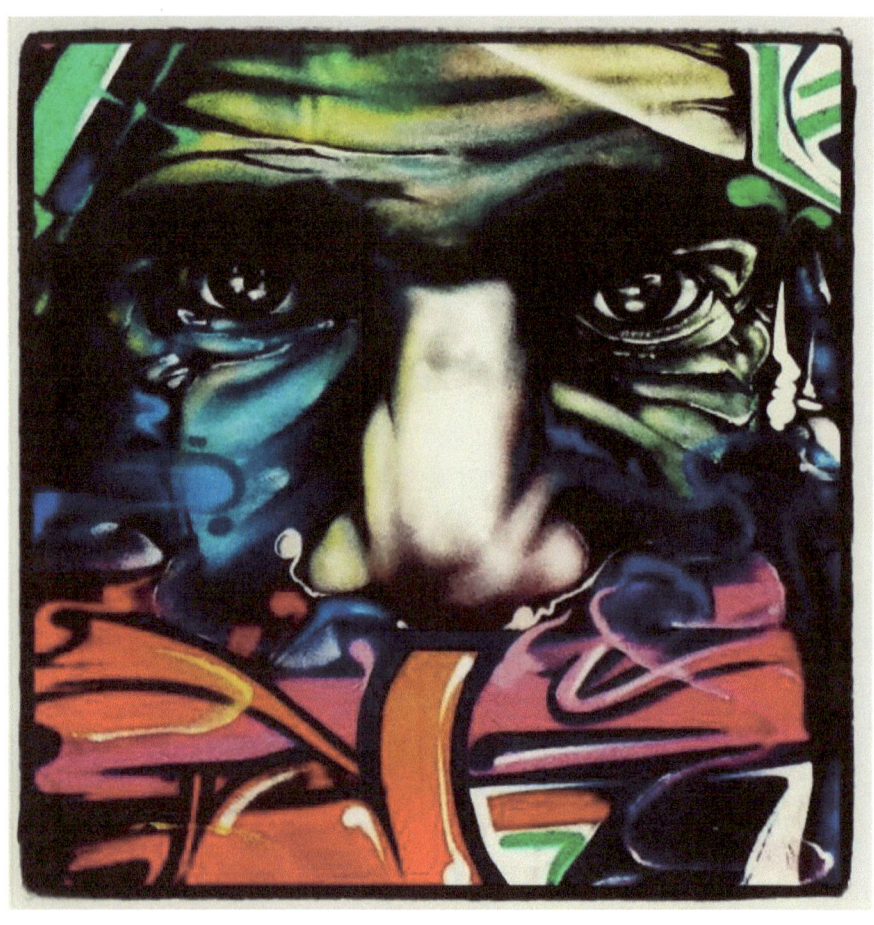

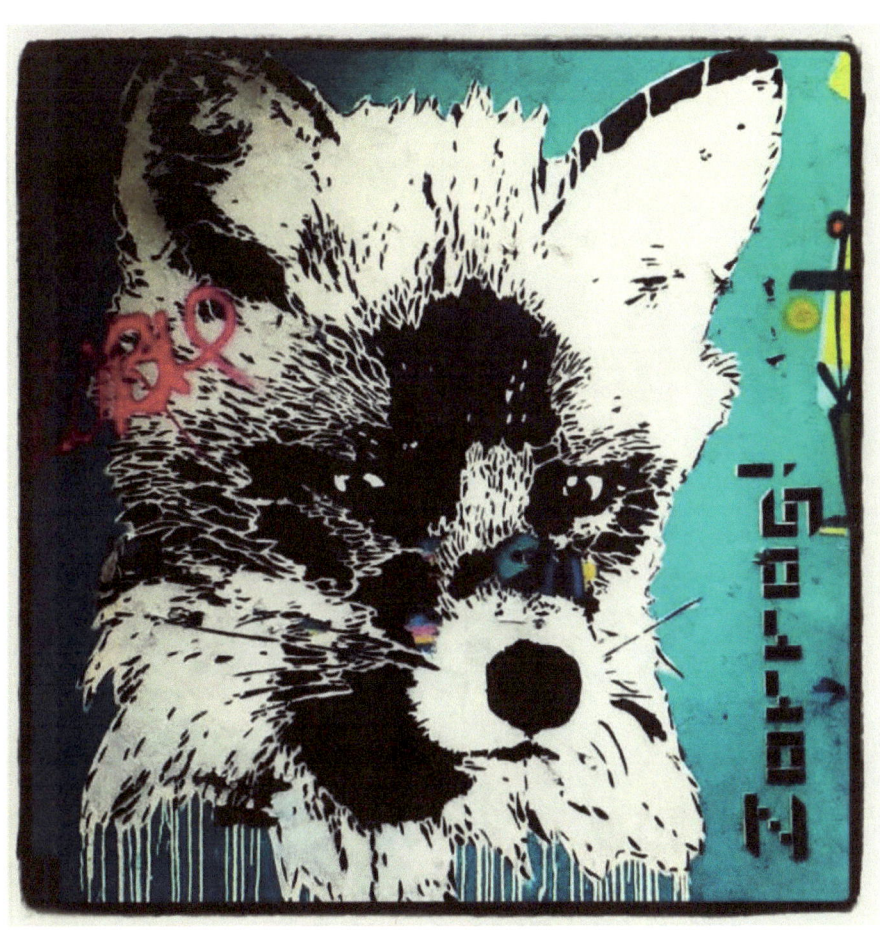

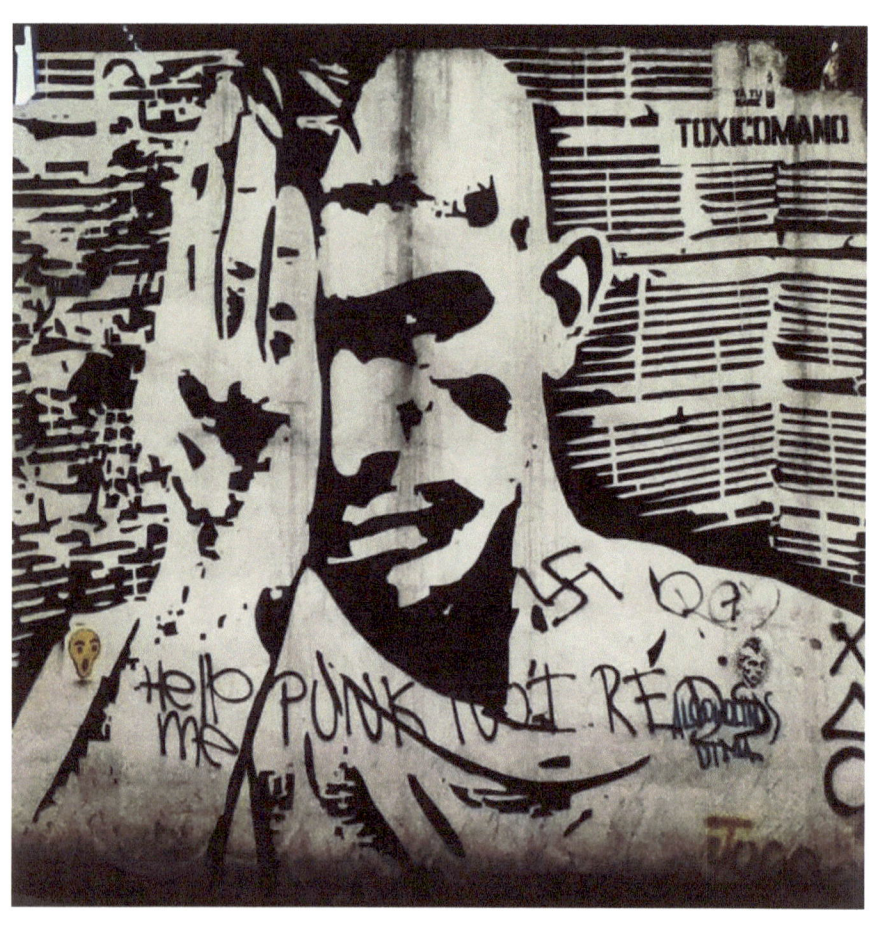

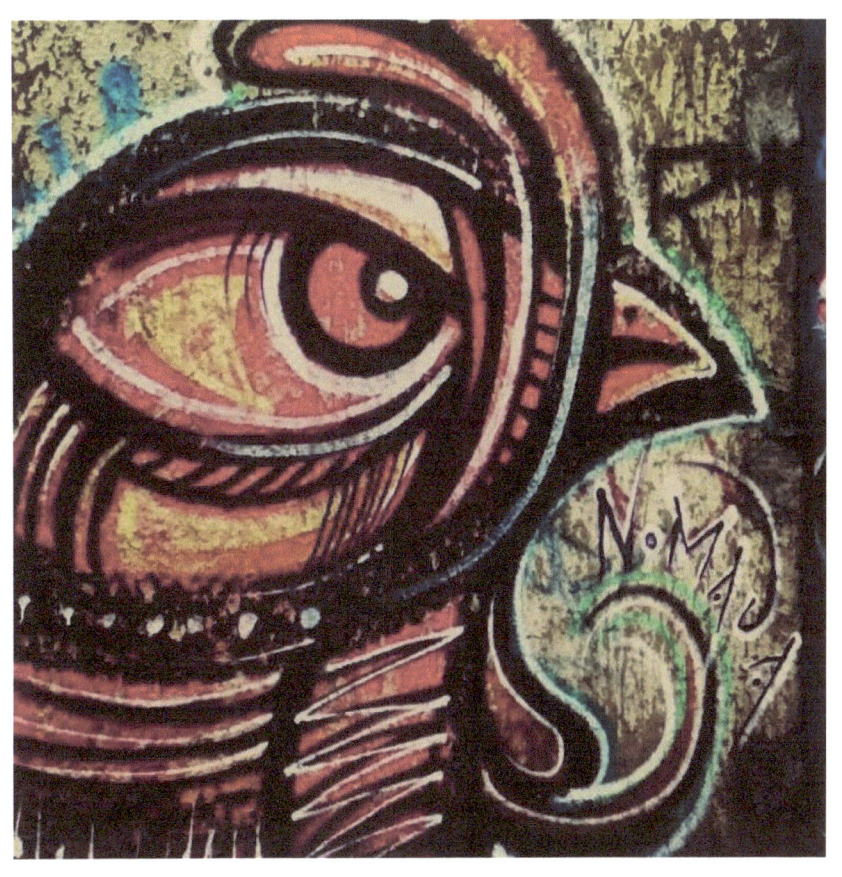

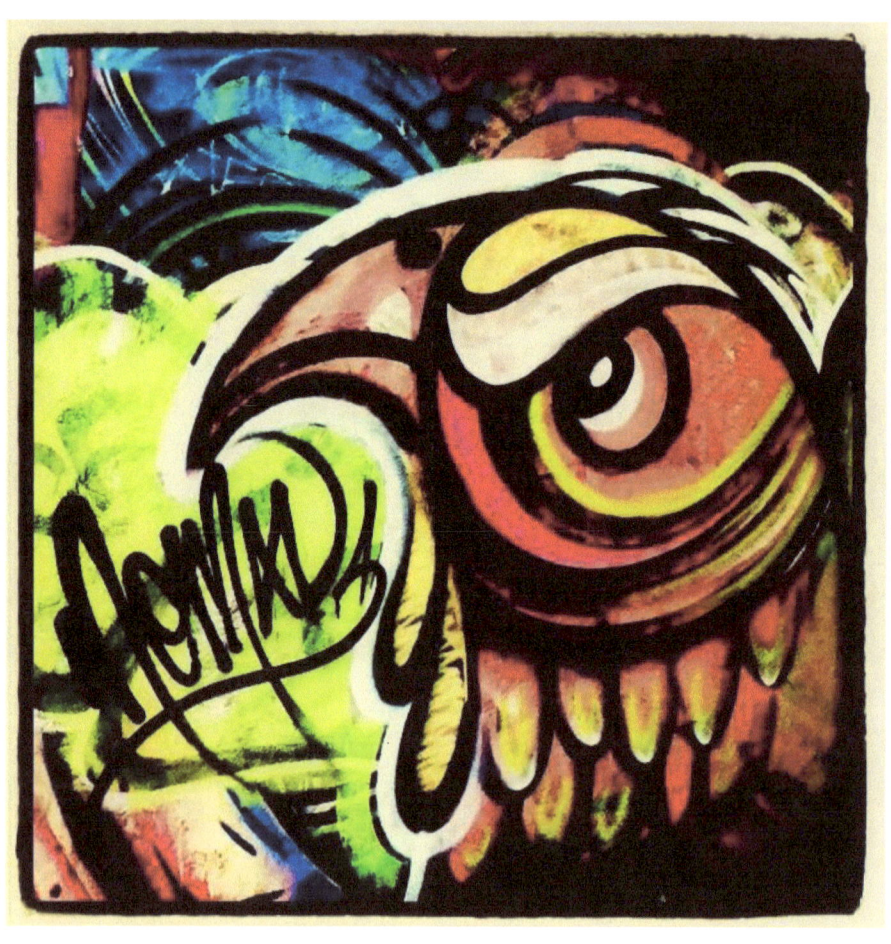

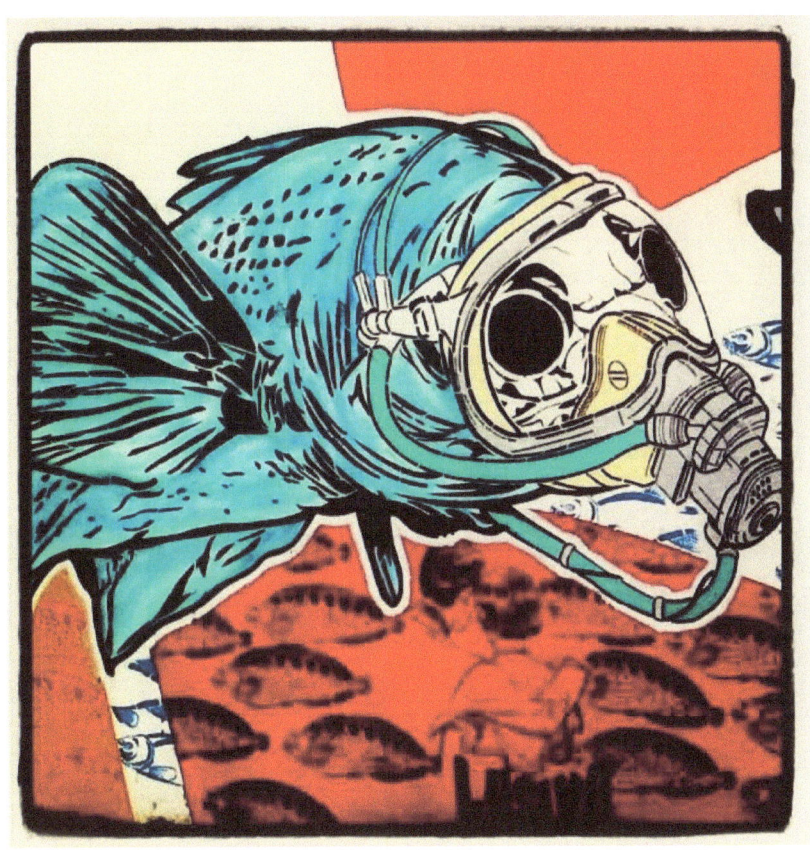

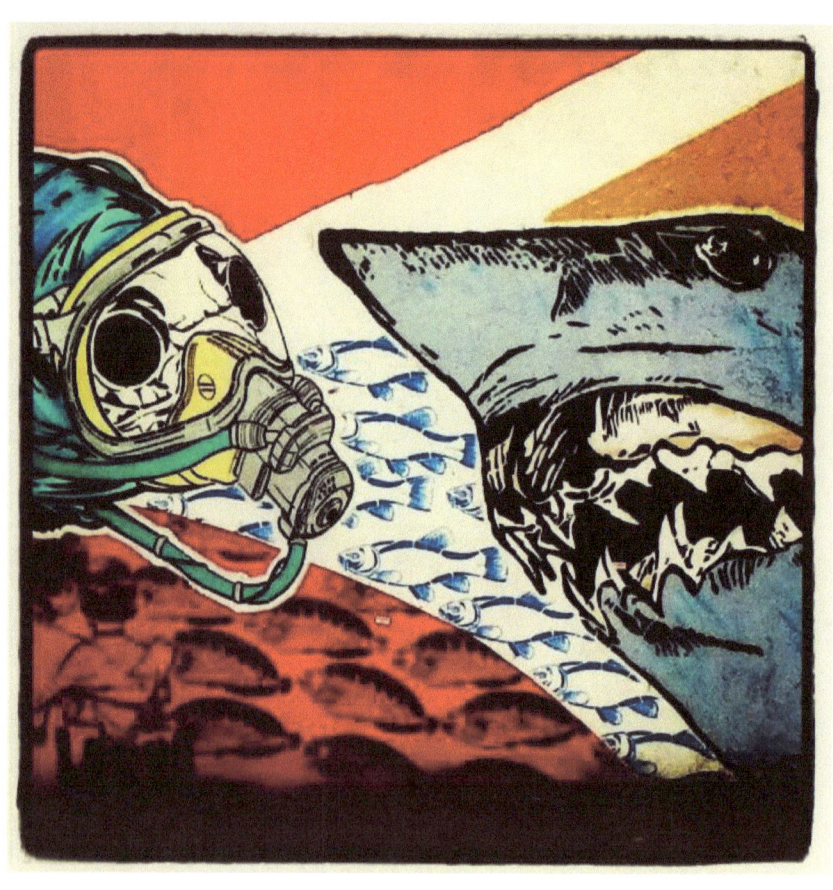

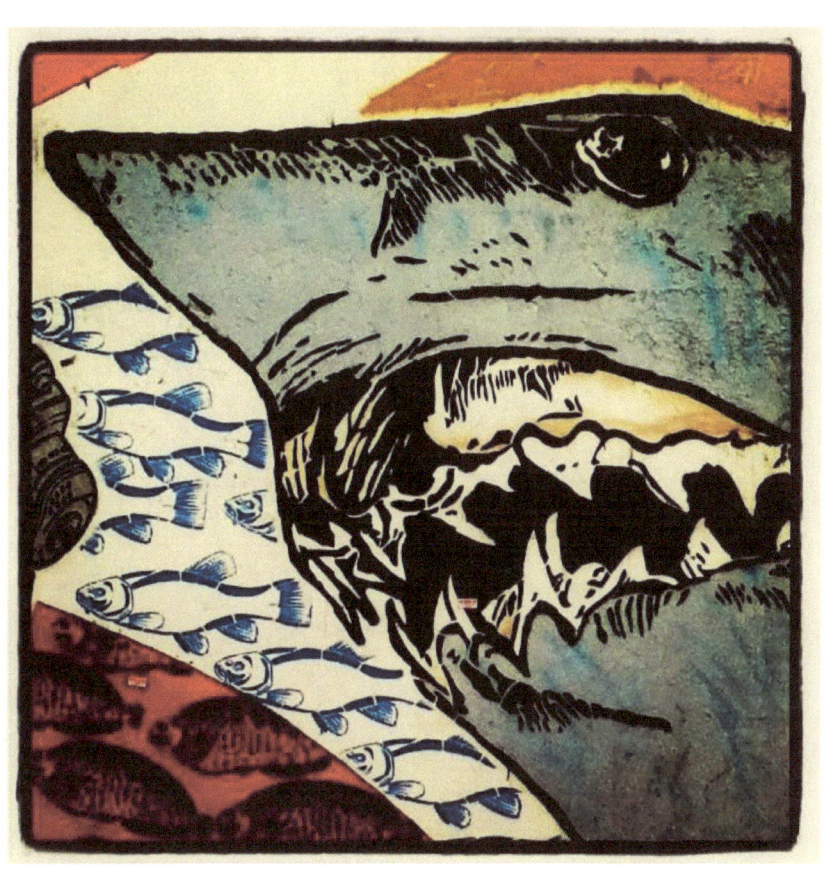

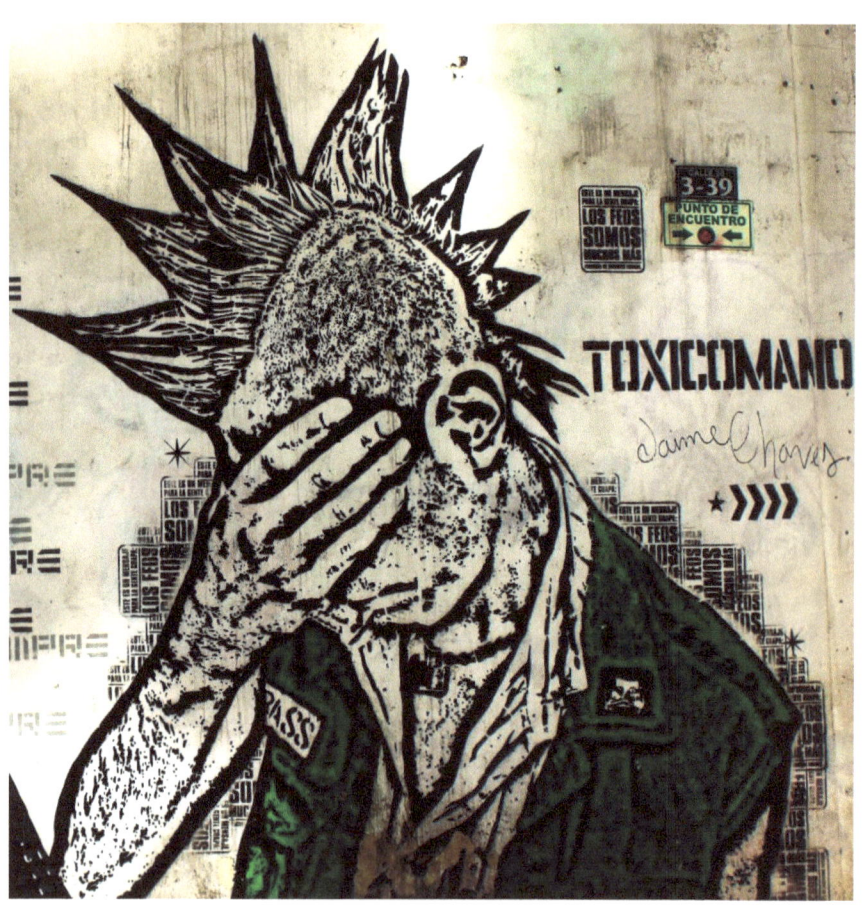

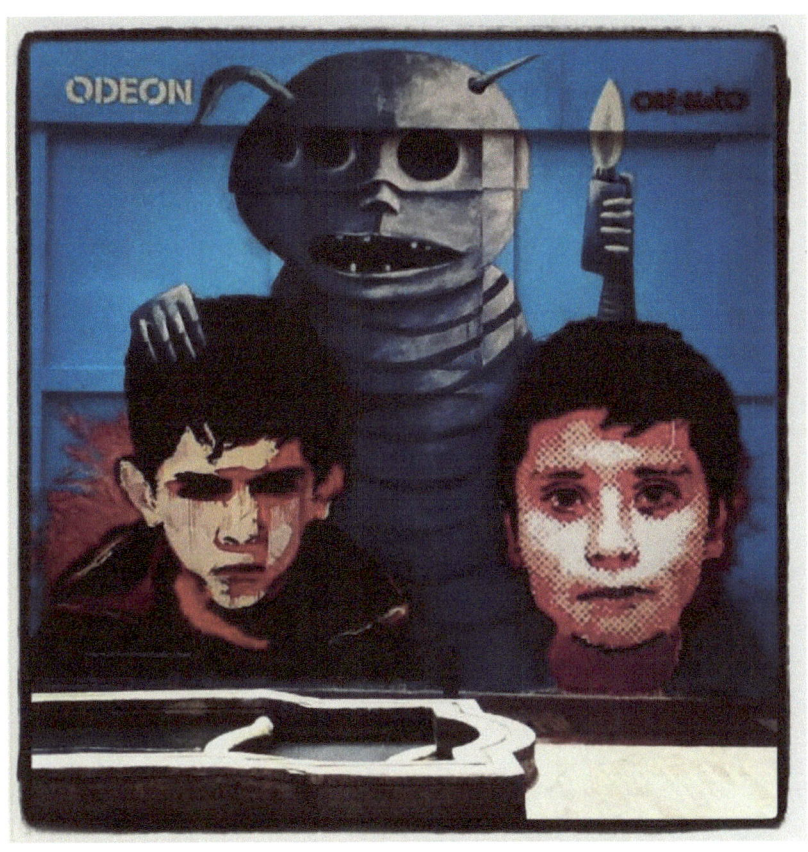

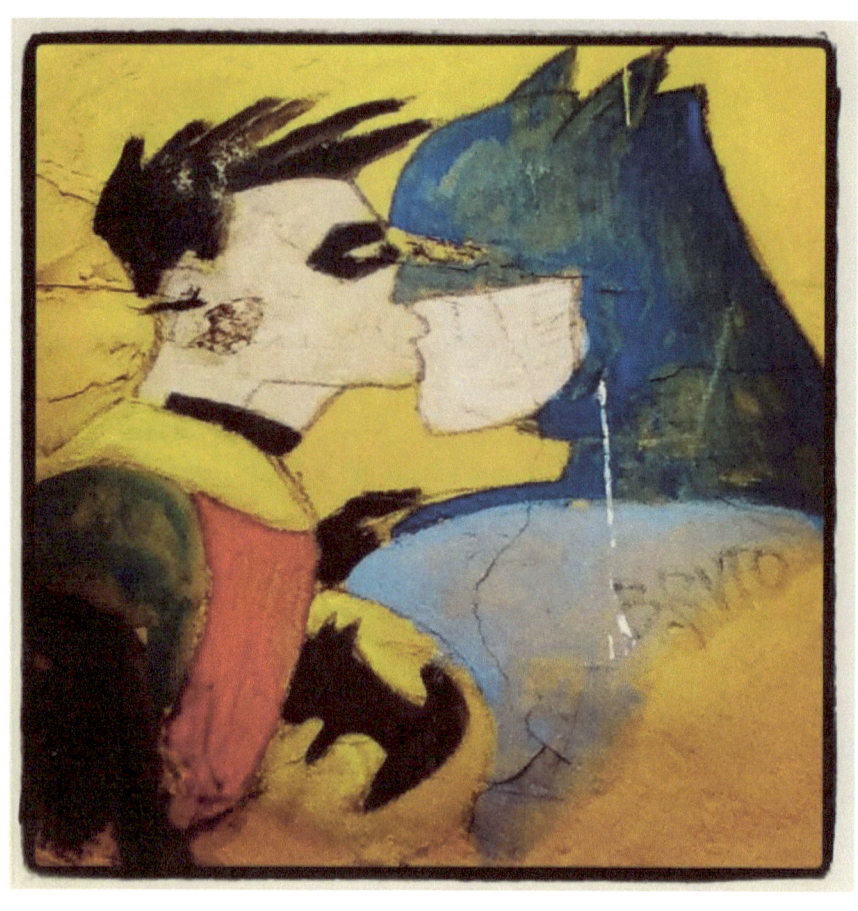

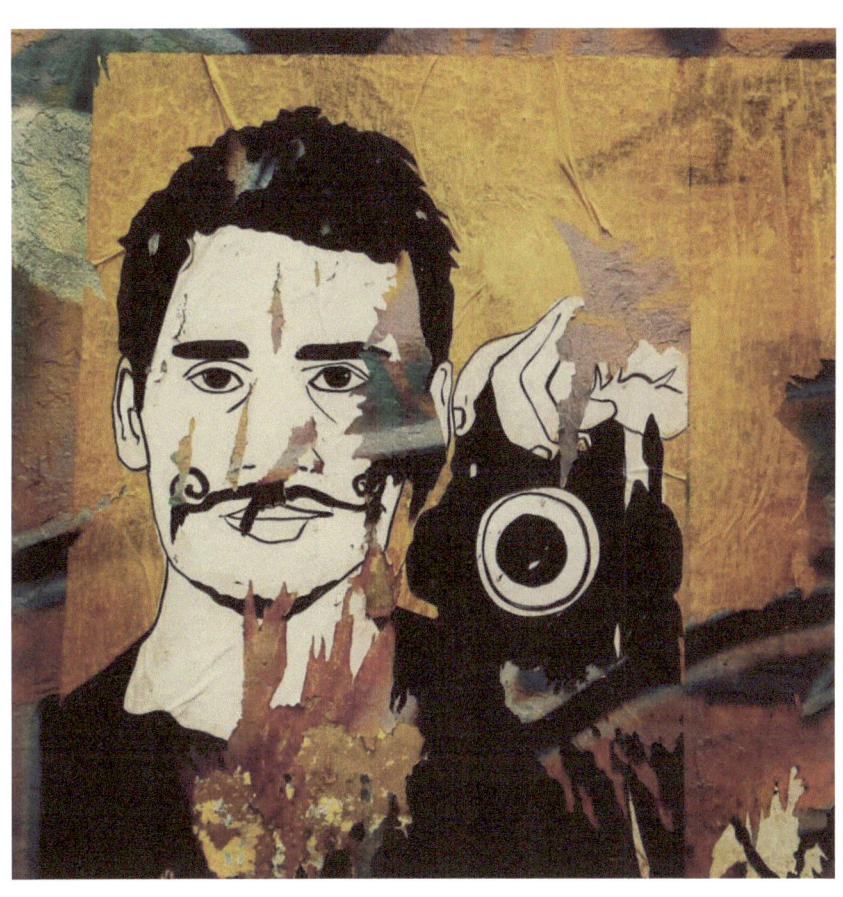

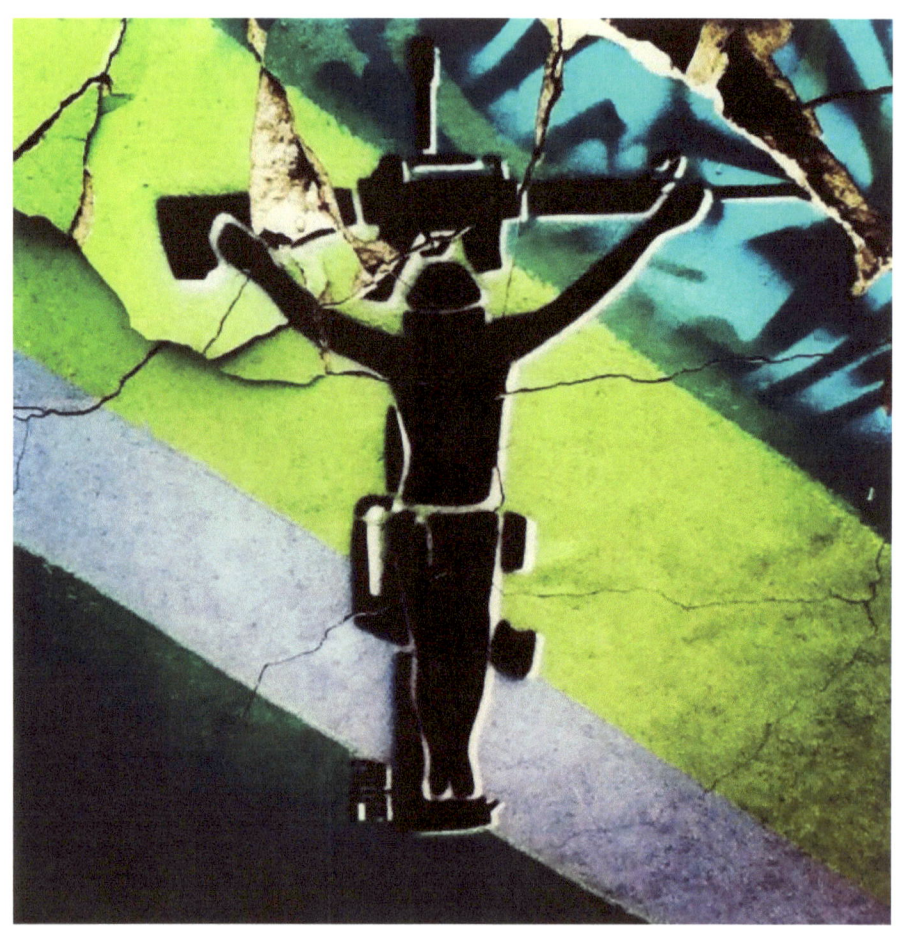

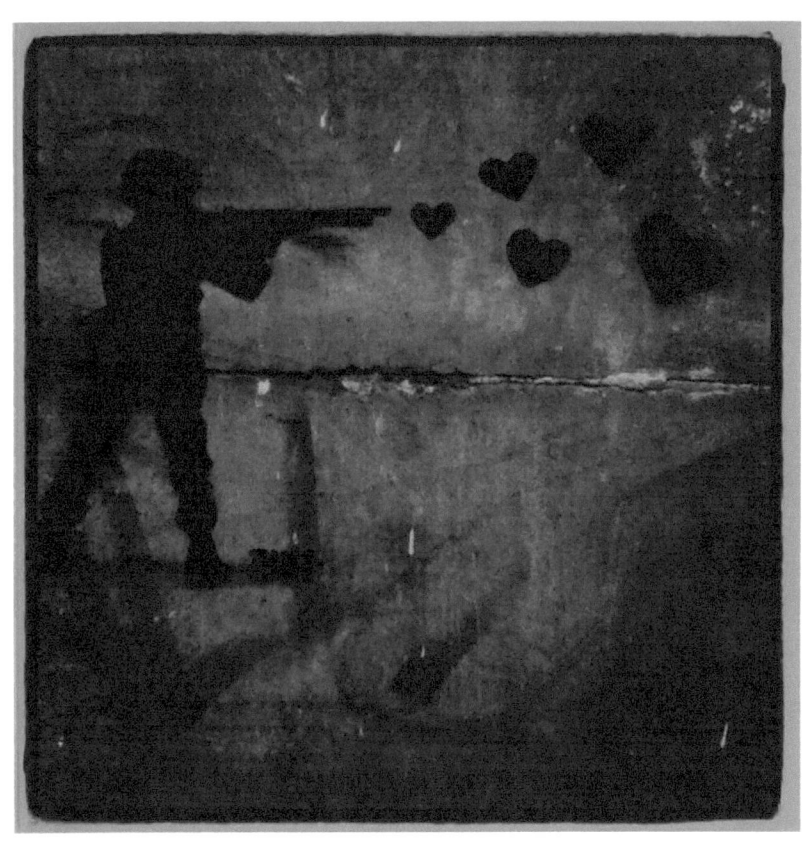

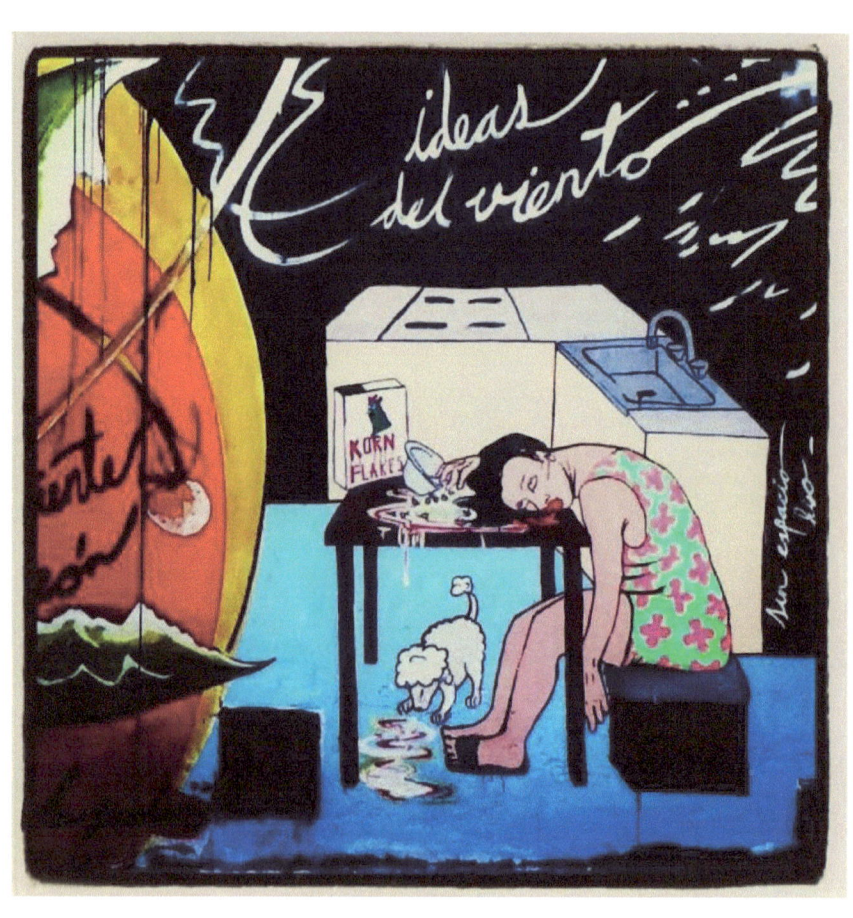

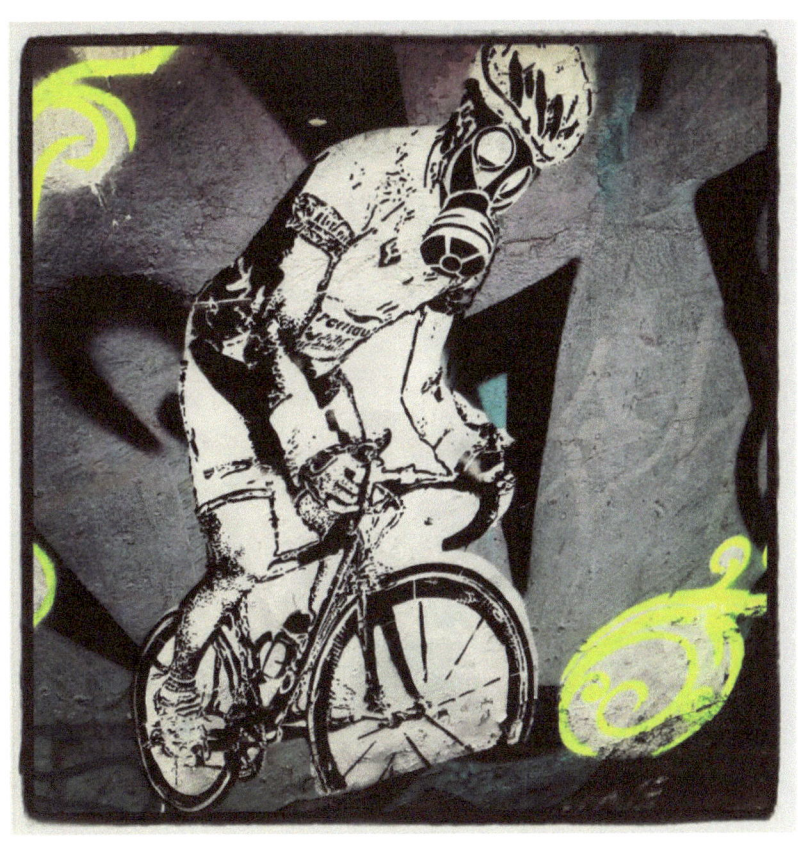

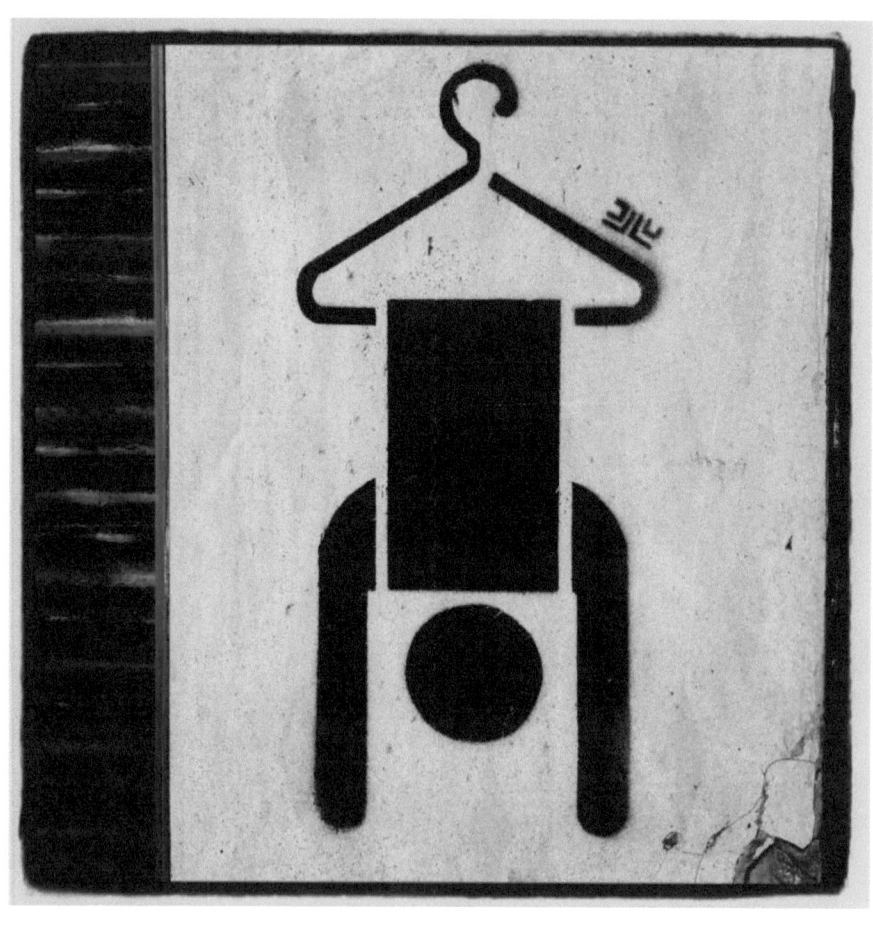

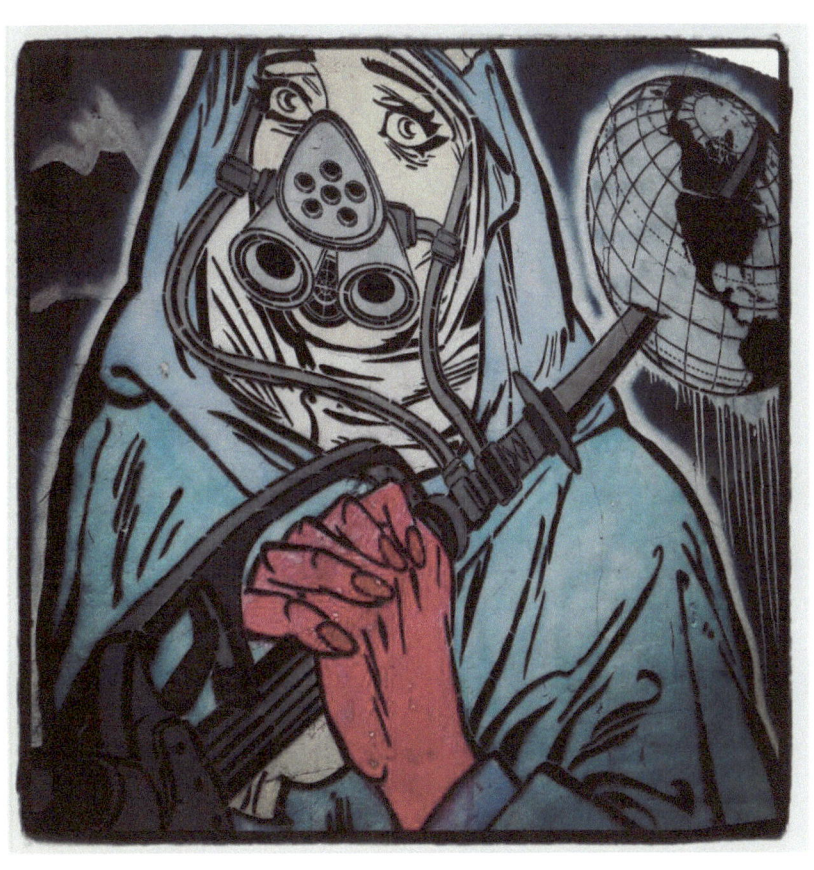

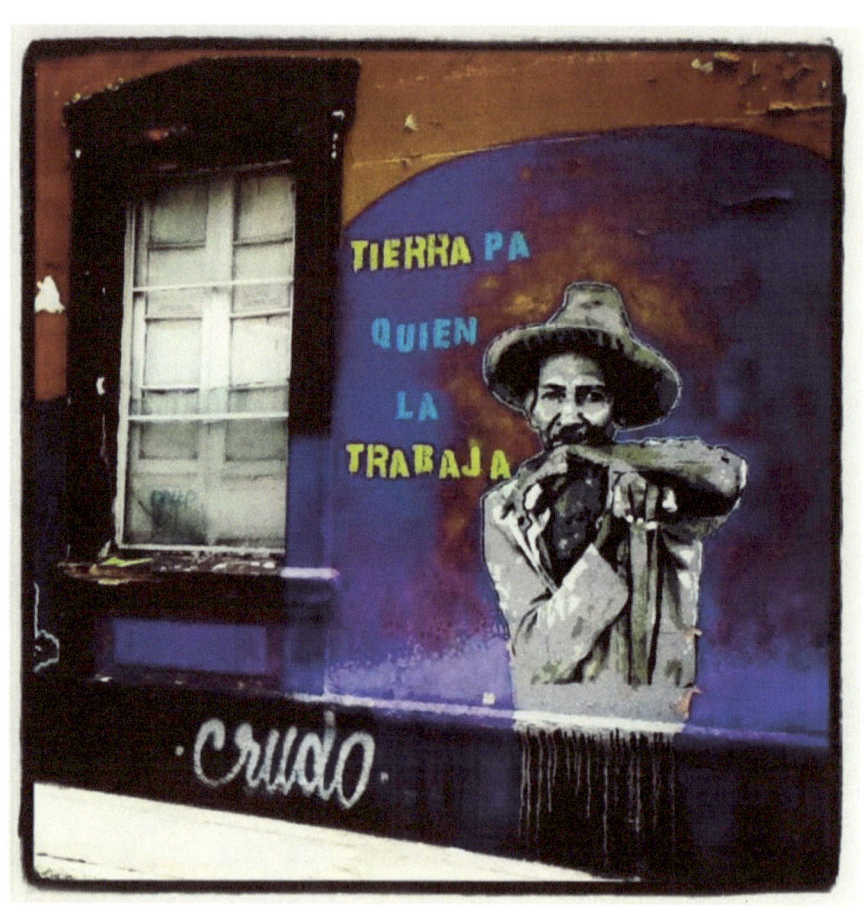

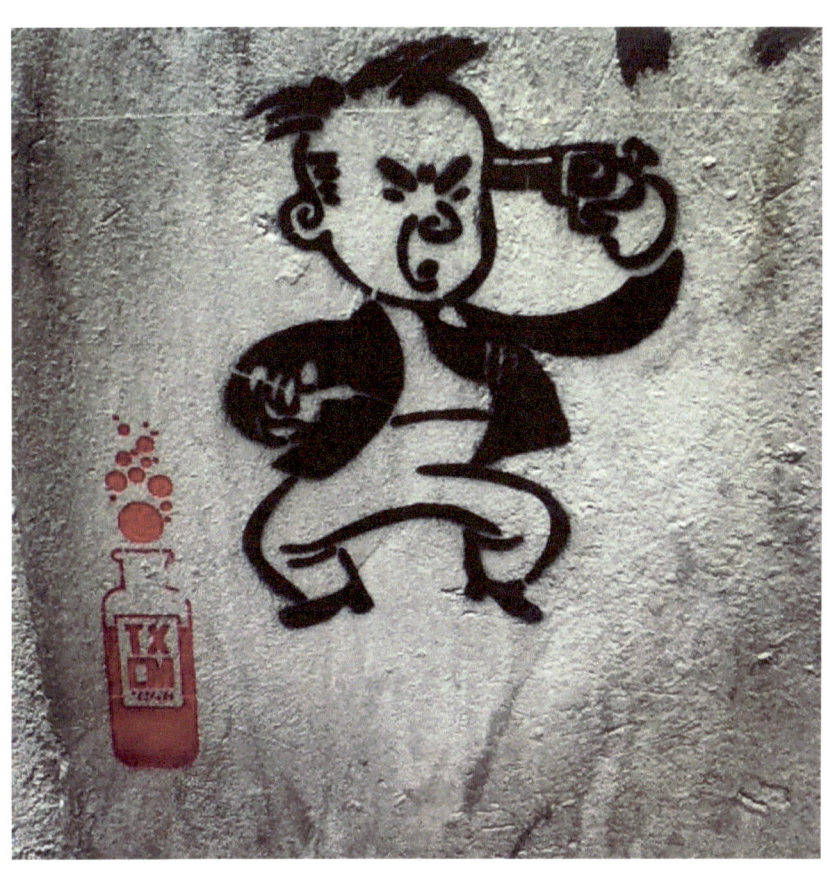

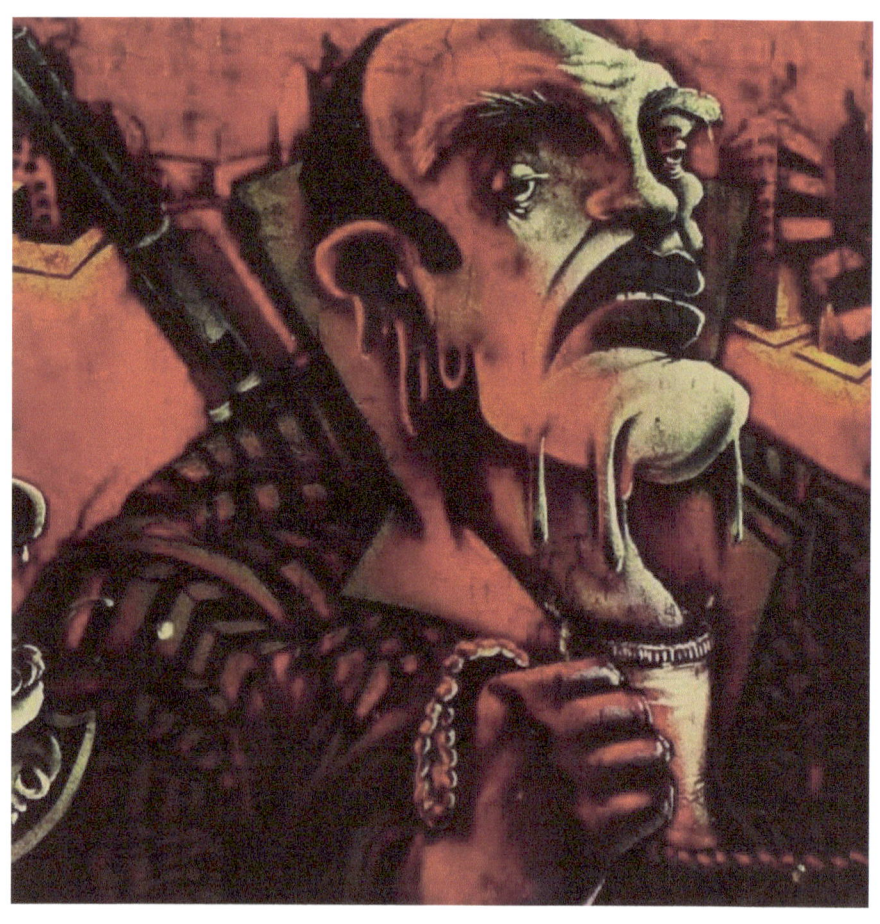

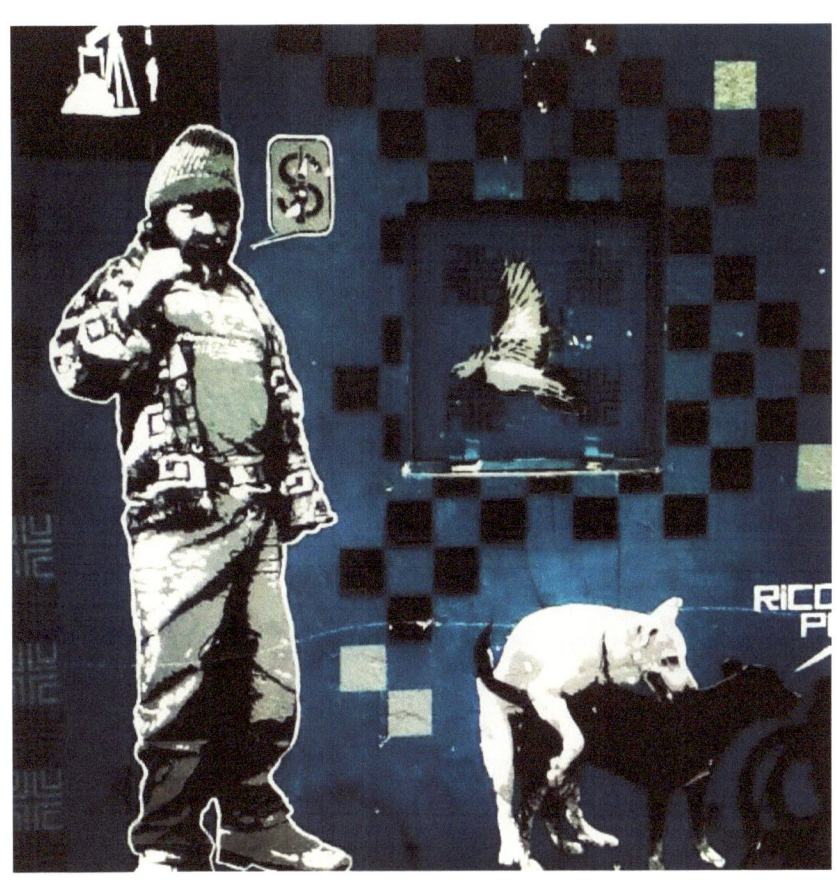

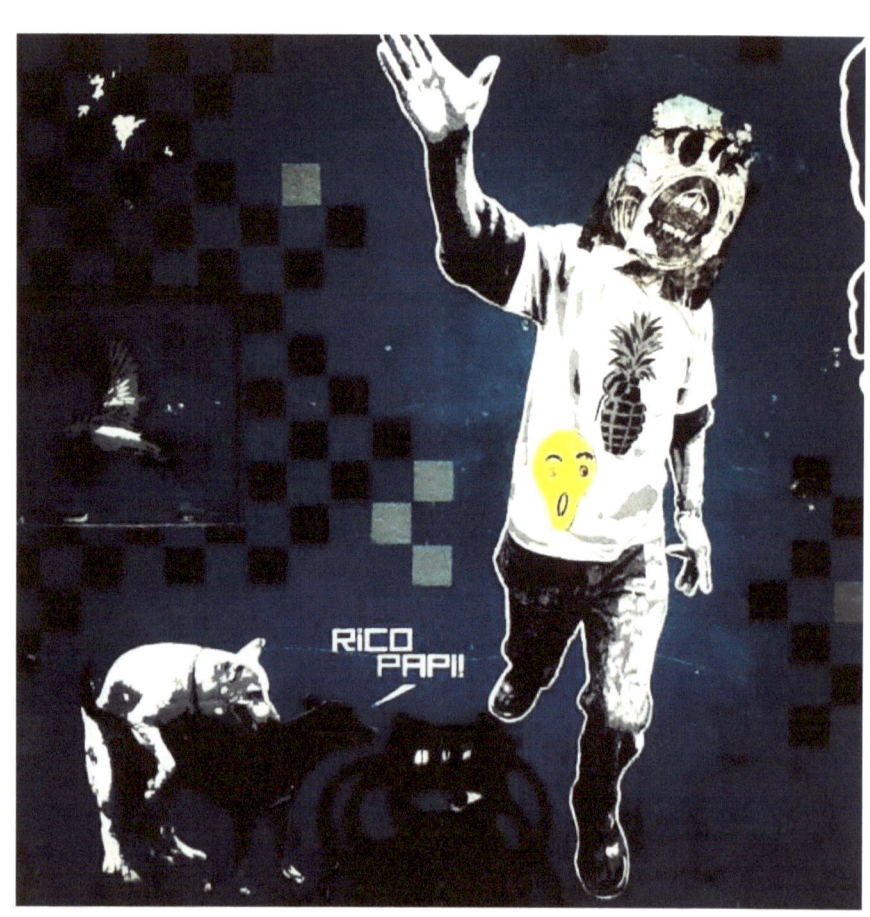

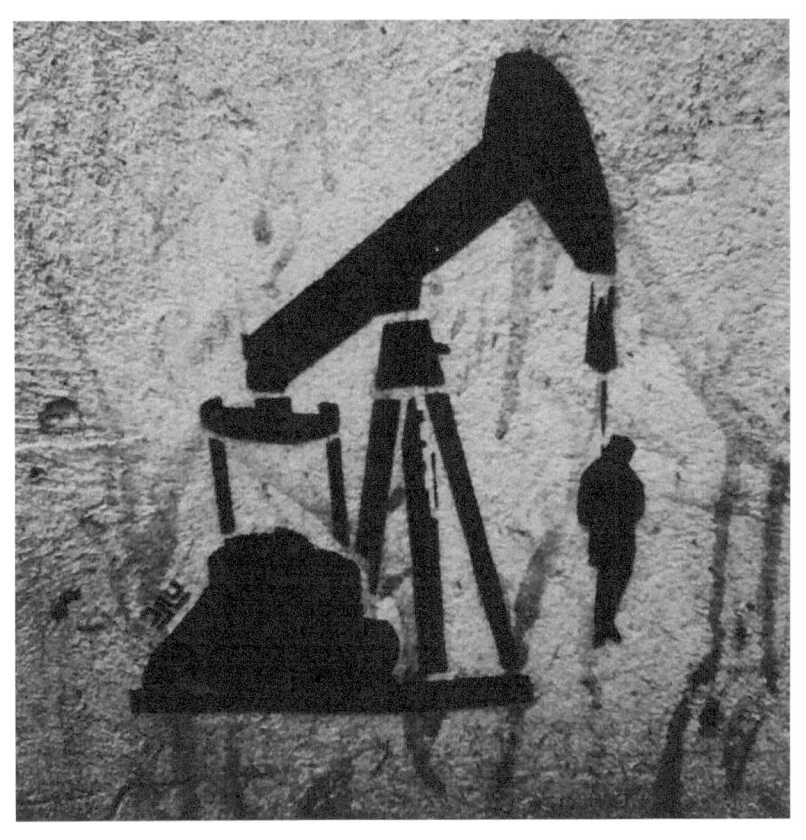

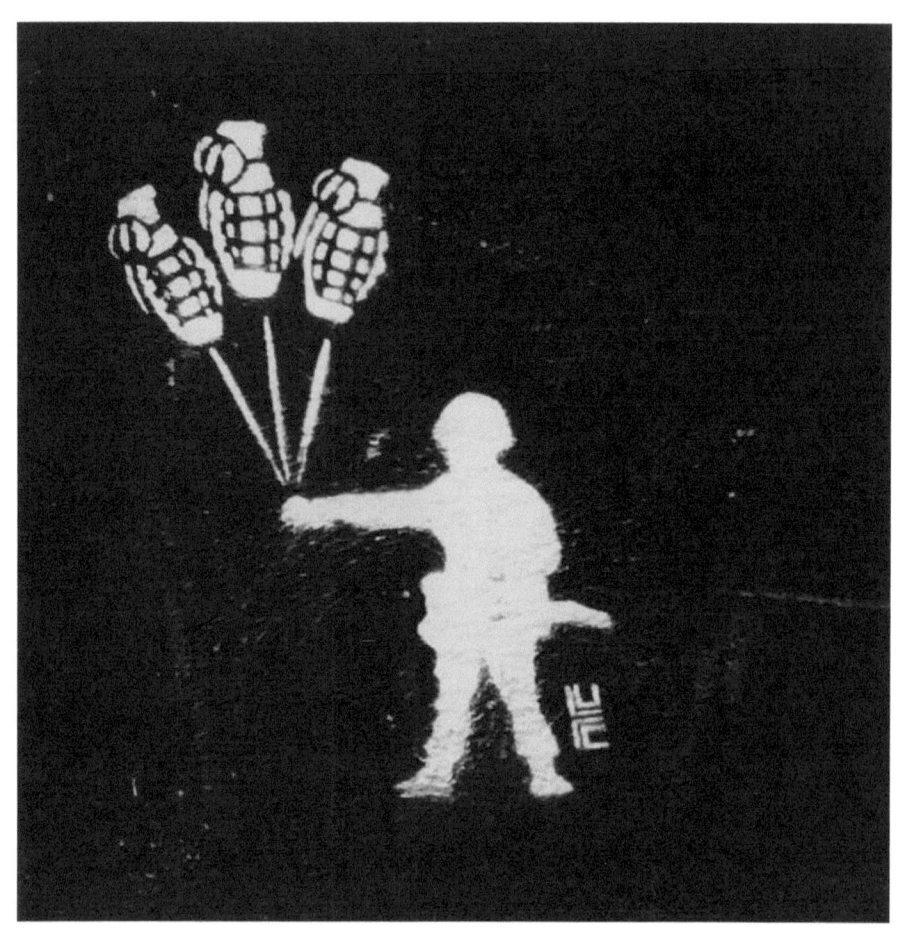

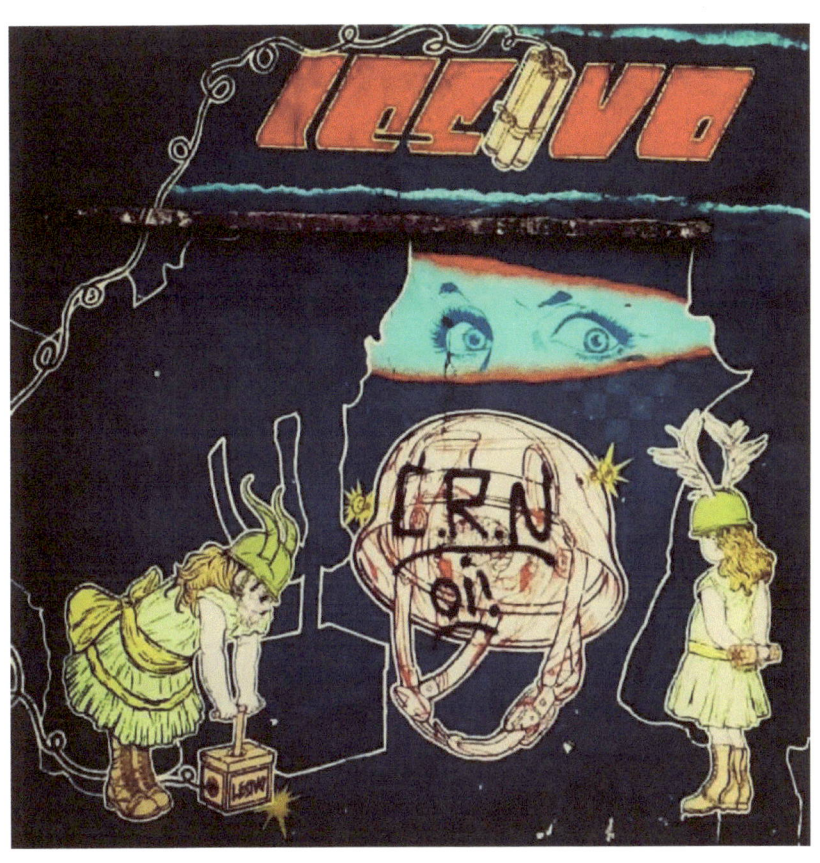

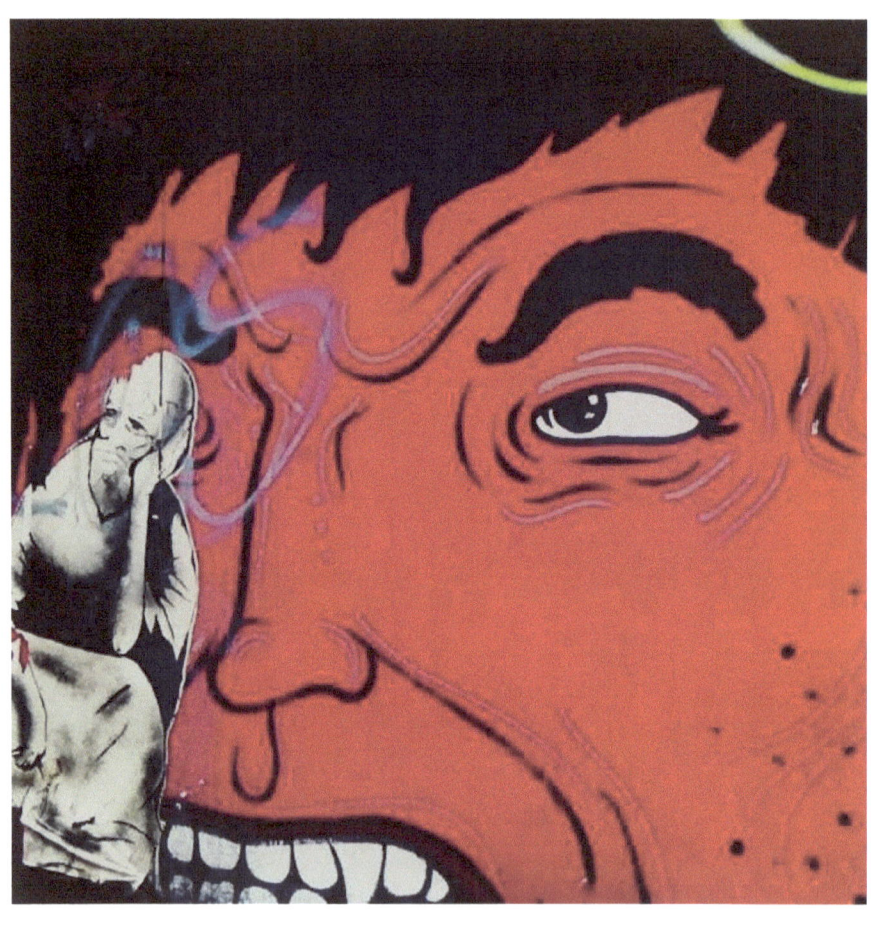

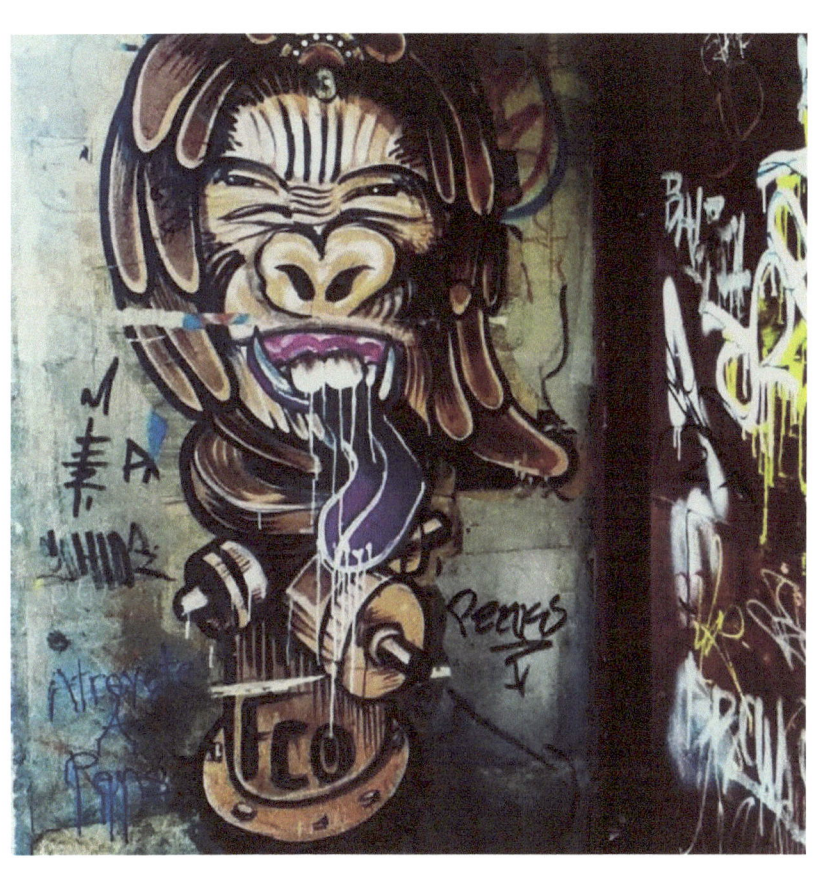

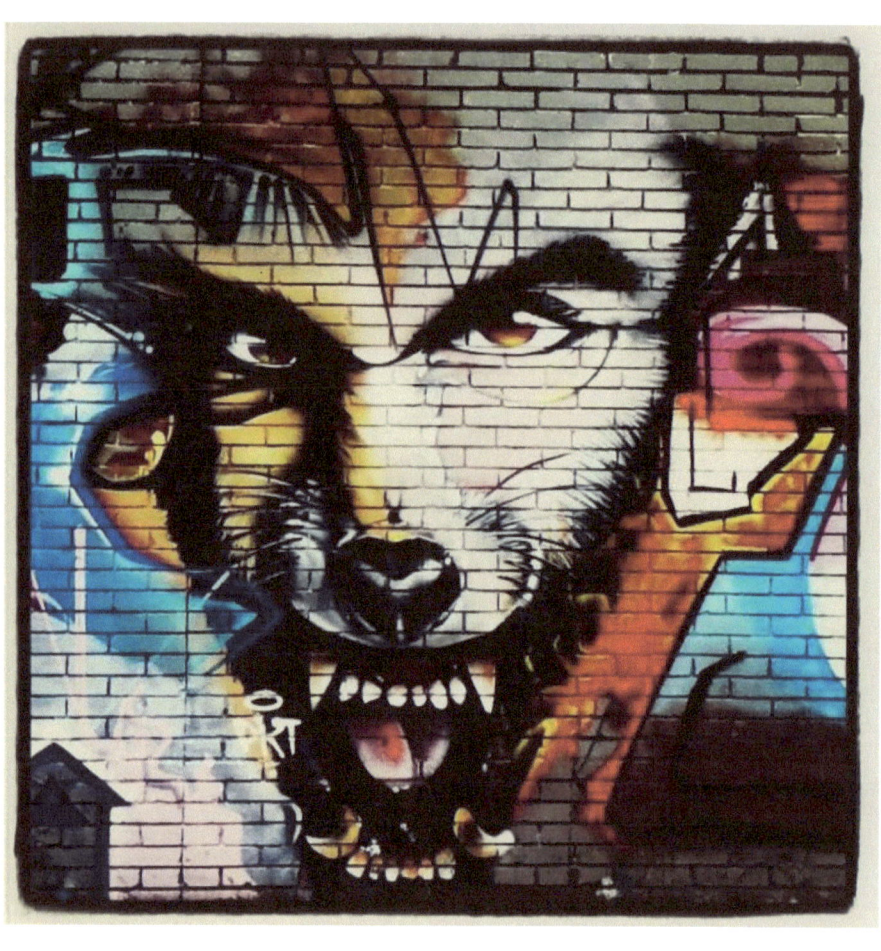

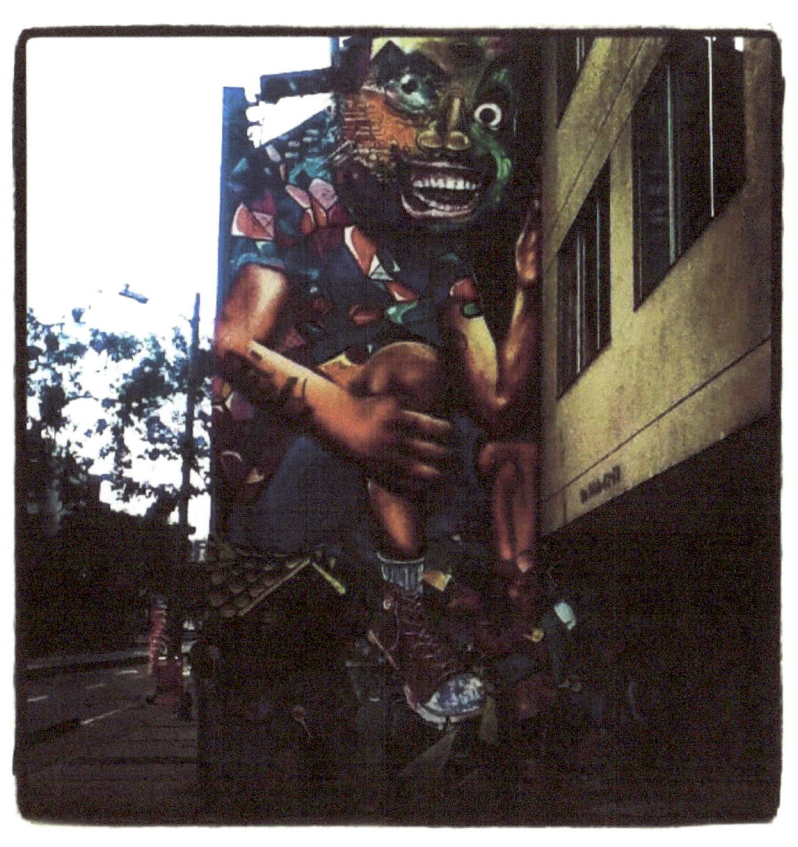

AUTHOR'S NOTE

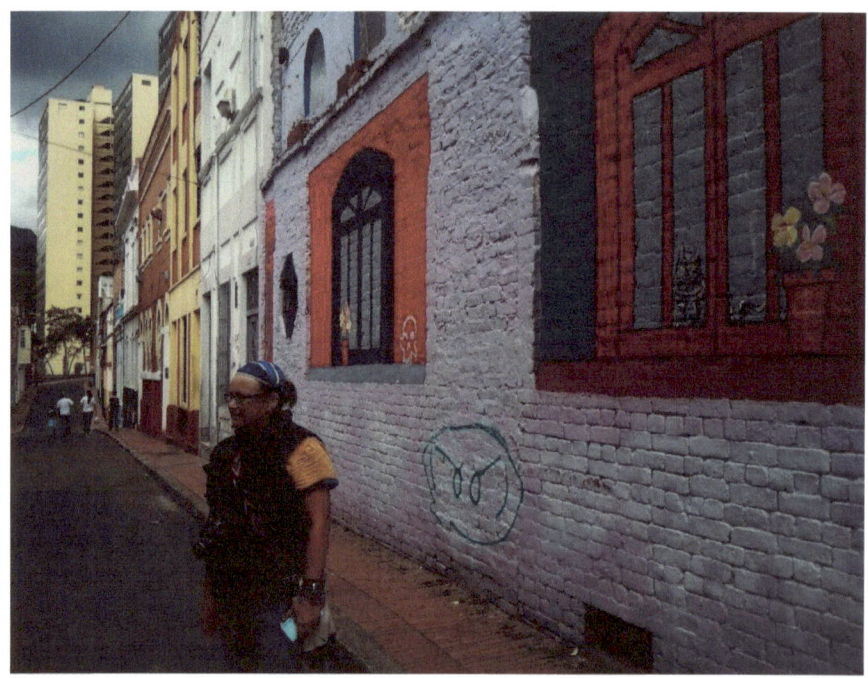

Pictured: Jacqueline Hadel in La Candelaria, in Bogota, Colombia. 2012.
photo by Erica Lederman

Jacqueline Hadel is a solo world traveler who never goes anywhere without a camera. Her passion for urban art all over the globe is what motivates her to choose destinations based on the level of public art displays so that she can document it in-depth. She believes life is to be lived. So, she lives it.

www.ingramcontent.com/pod-product-compliance
Lightning Source LLC
Chambersburg PA
CBHW040922180526
45159CB00002BA/573